There is nothing in this world as invisible as a monument
Robert Musil

VOLTE-FACE

PHOTOGRAPHS BY

OLIVER CURTIS

ESSAY BY

GEOFF DYER

DEWI LEWIS PUBLISHING

volte-face

noun: volte-face; plural noun: volte-faces

1. an act of turning round so as to face in the opposite direction.
2. an abrupt and complete reversal of attitude, opinion, or position.
3. a reversal, as in policy; an about-face.

In the autumn of 2012, on a work assignment in Cairo, I took the opportunity to visit the Pyramids of Giza. Along with a handful of other tourists I climbed the sandy path from the ticket office, past enthusiastic hawkers, offers of camel rides, and found myself standing before the first and largest pyramid in the necropolis dedicated to the Pharaoh Khufu.

Walking around the base of the tomb, I eventually found myself looking back in the direction of my arrival, the pyramid behind me. Intersecting the horizon under a veil of smog lay the city of Giza. In front of me and beneath my feet, the sand of the desert adorned with an assortment of human detritus; litter, pieces of rusted metal, a large rubber washer and a torn hessian sack. In the middle distance I could see a newly constructed golf course, its fairways an intense green under the late morning sun. This visual sandwich of contrasting colour, texture and form intrigued me, not simply for the photograph it made, but also because of the oddness of my position standing at one of the great wonders of the world, facing the 'wrong' way.

I moved on to the neighbouring pyramid, Khafre. Turning away once again, I spotted an office desk tossed randomly onto the roof of a stone building. Beyond were silhouettes of tourists on camel rides and, on the skyline, a large horizontal sign.

Since my visit to Egypt, I have made a point of turning my back on more of the world's most photographed monuments and historic sights and have become obsessed with these counter views, these about-faces. Much of what is seen when turning away may intitially seem mundane, a disorganisation of space and people, the antithesis of the construction that stands behind. The landscape is less pampered, somewhat ruffled and unkempt, perhaps because these are zones we usually pass through to get to somewhere else rather than destinations in their own right.

These landscapes are in every sense over-looked. In photographic terms they are places to look from, not at, emitting a quiet history, a subtle narrative often at odds with the neighbouring monolithic structure they face or surround. They may also be places of work; janitors and security guards in reflective or playful mood, a cleaner taking shelter from the midday sun amongst a monument's giant floodlights, an office worker asleep on the lawn outside the White House. These people exhibit a lack of awe born from daily exposure.

At every location, despite its absence from the photograph, my view was constantly suffused with the presence of the construction behind me. The camera lens effectively became a nodal point between the two and, by giving the photograph the title of the unseen partner, this duality could be emphasised.

Volte-face is an invitation to turn around and see afresh the over-photographed sites of the world, to send our gaze elsewhere, to favour the incidental over the monumental.

Oliver Curtis
June 2016

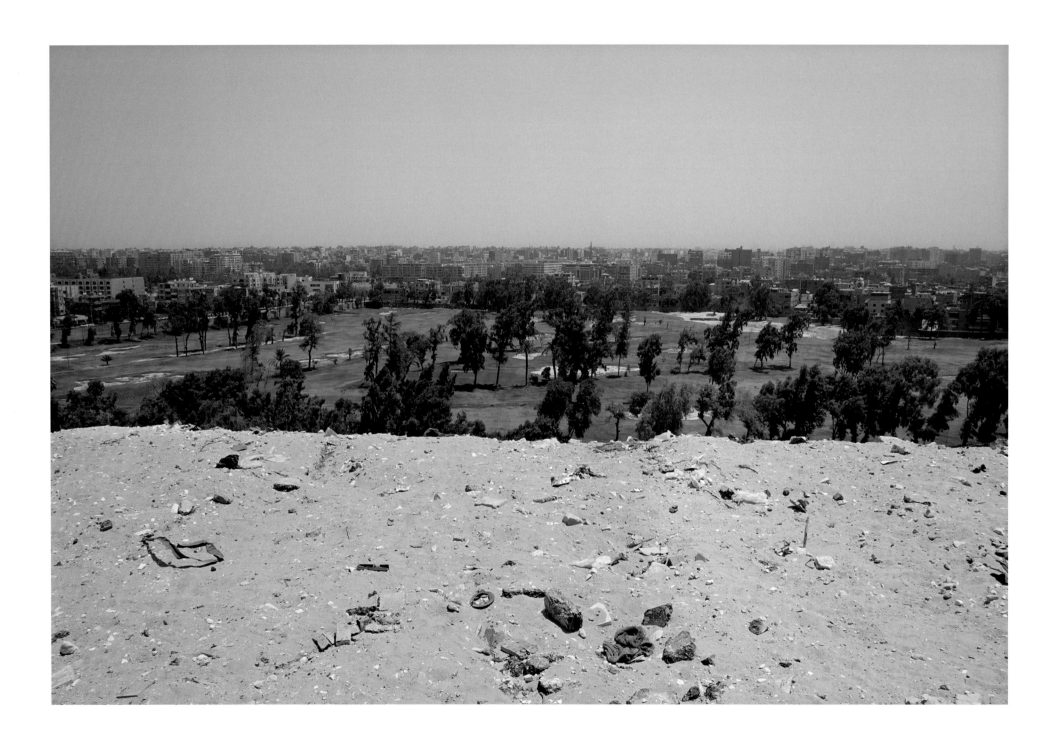

Pyramid of Khufu, Giza, Egypt

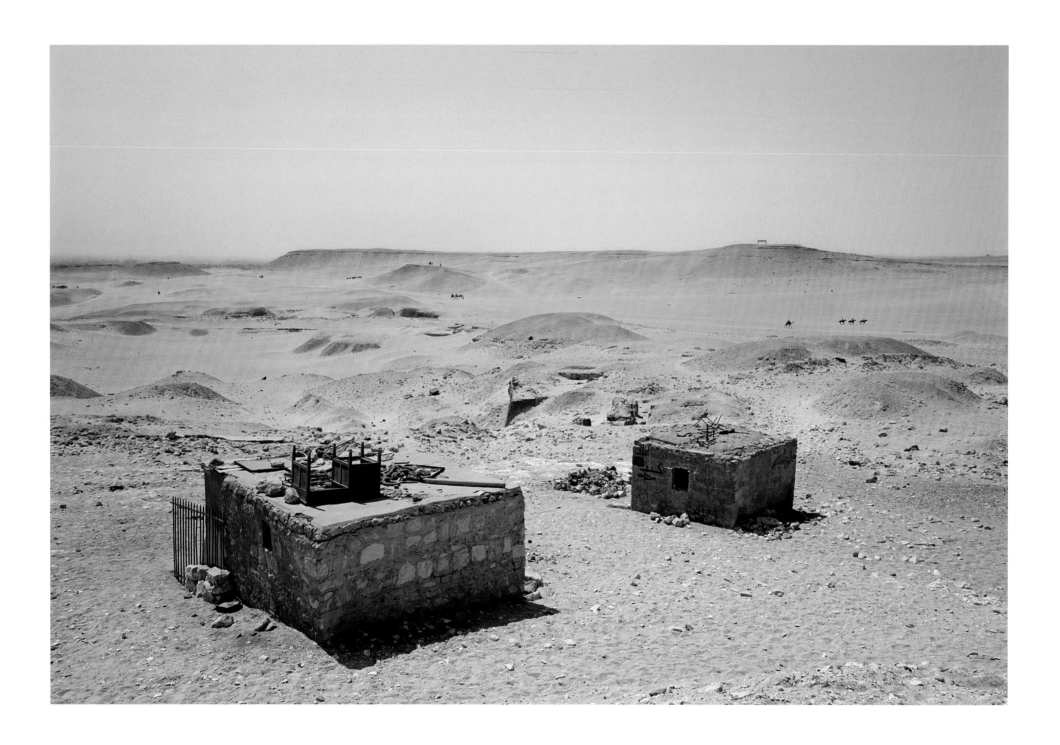

Pyramid of Khafre, Giza, Egypt

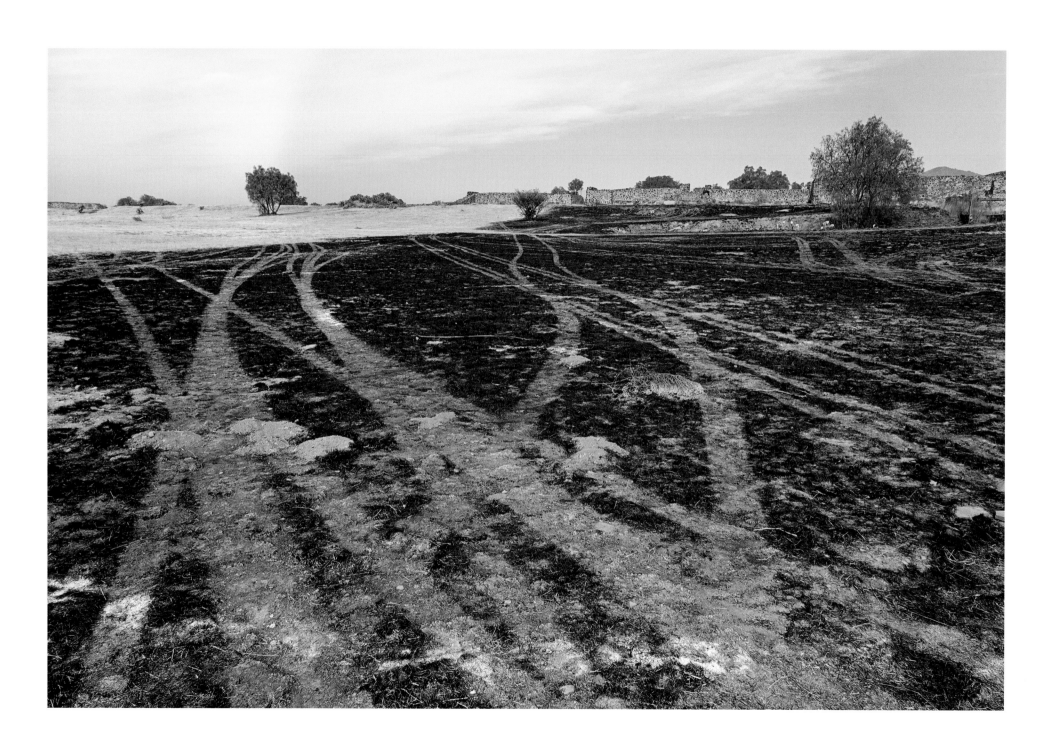

Pyramid of the Sun, Teotihuacan, Mexico

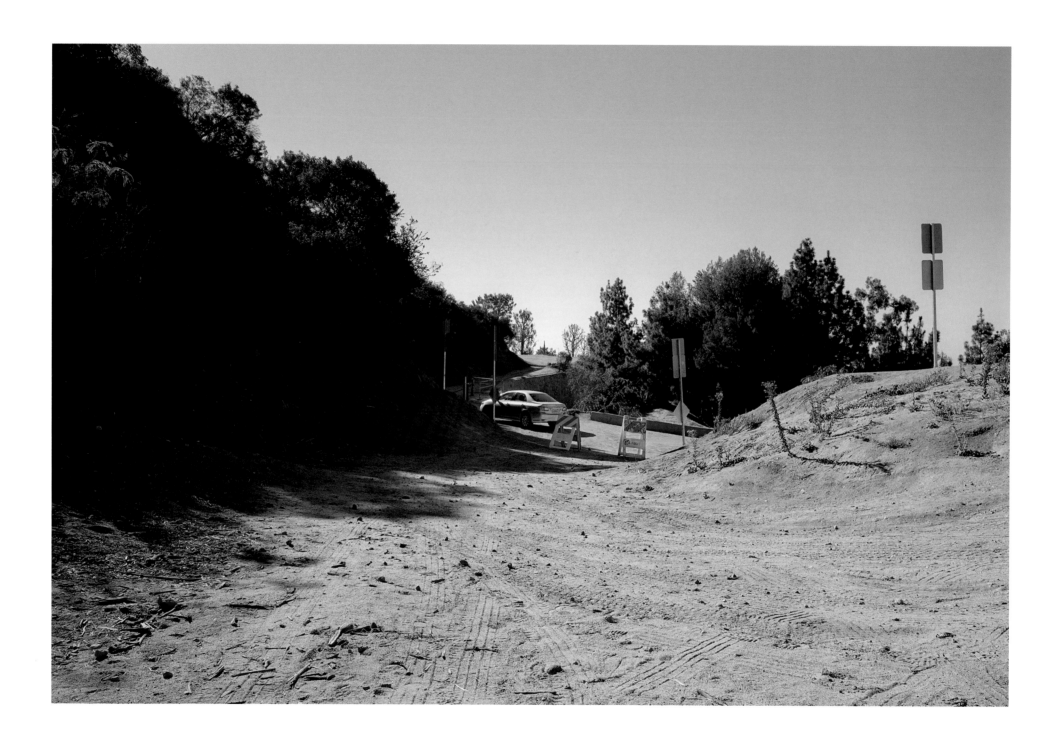

Hollywood Sign, Los Angeles, USA

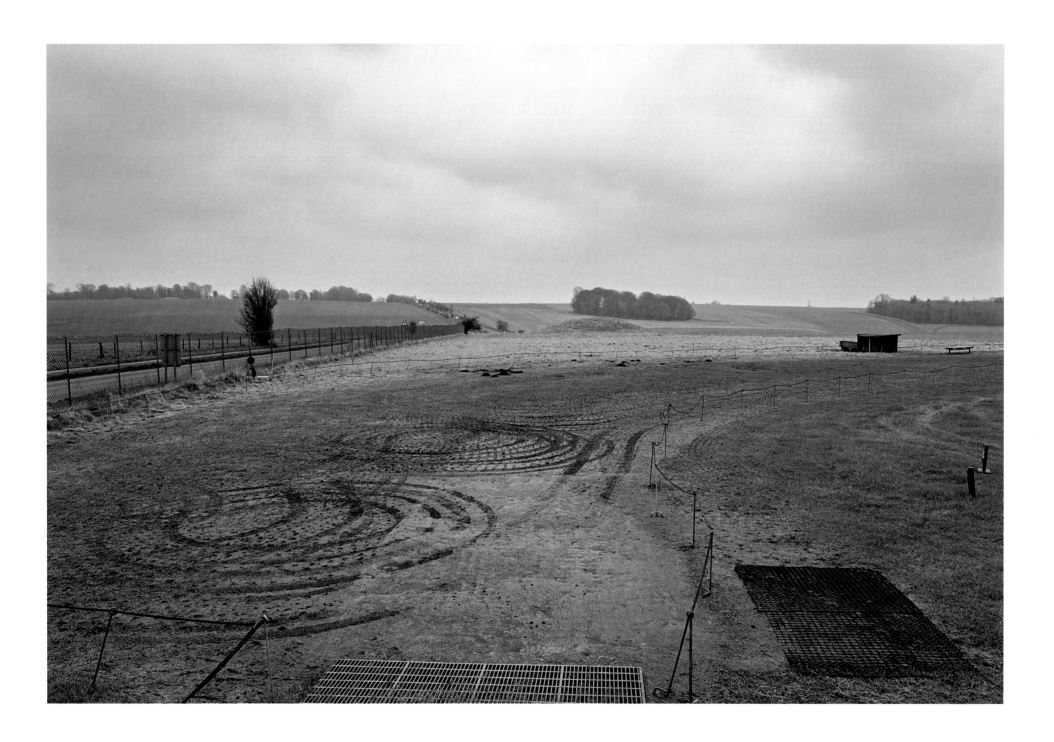

Stonehenge, Amesbury, UK

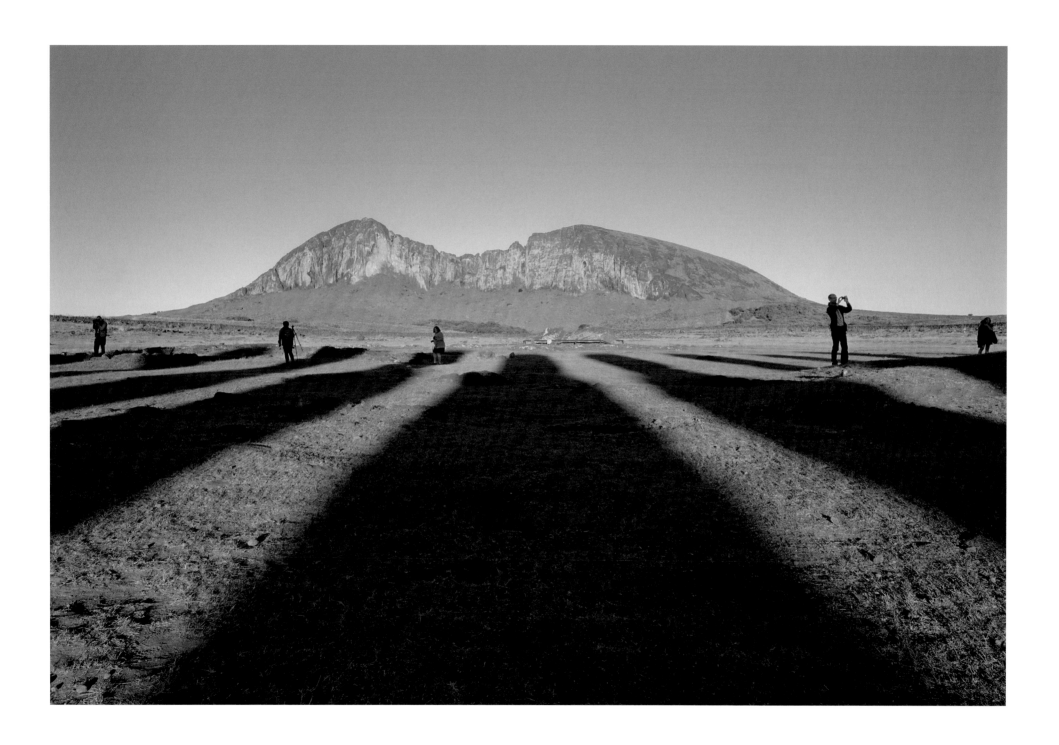

Ahu Tongariki, Rapa Nui (Easter Island), Chile

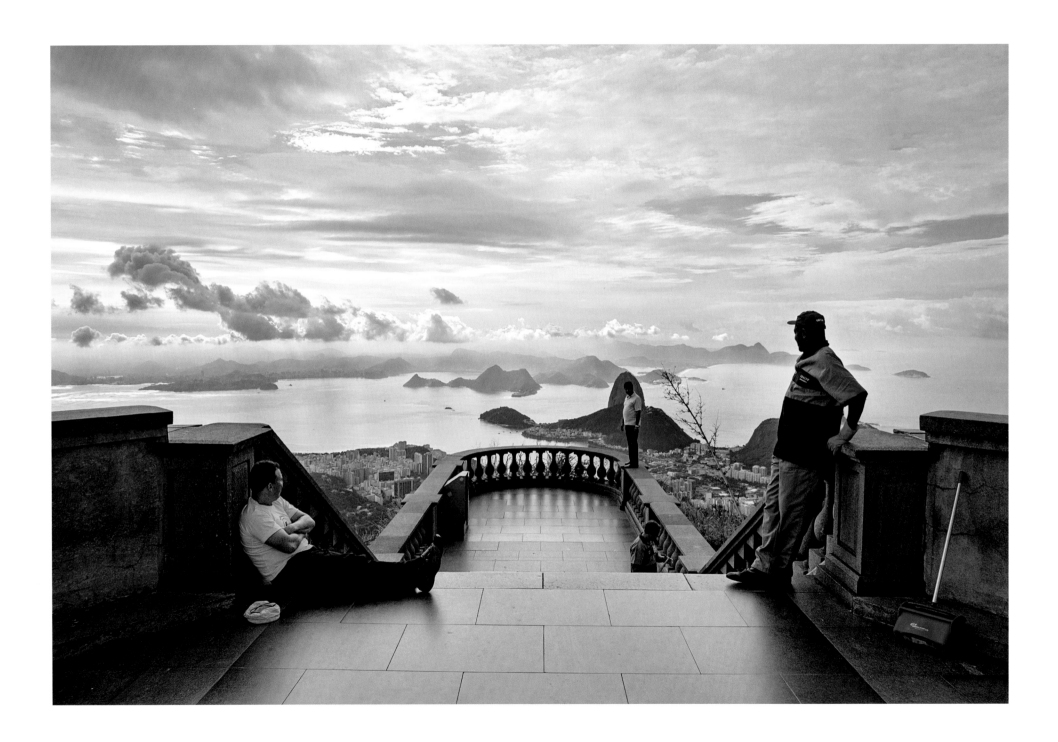

Christ the Redeemer, Rio de Janeiro, Brazil

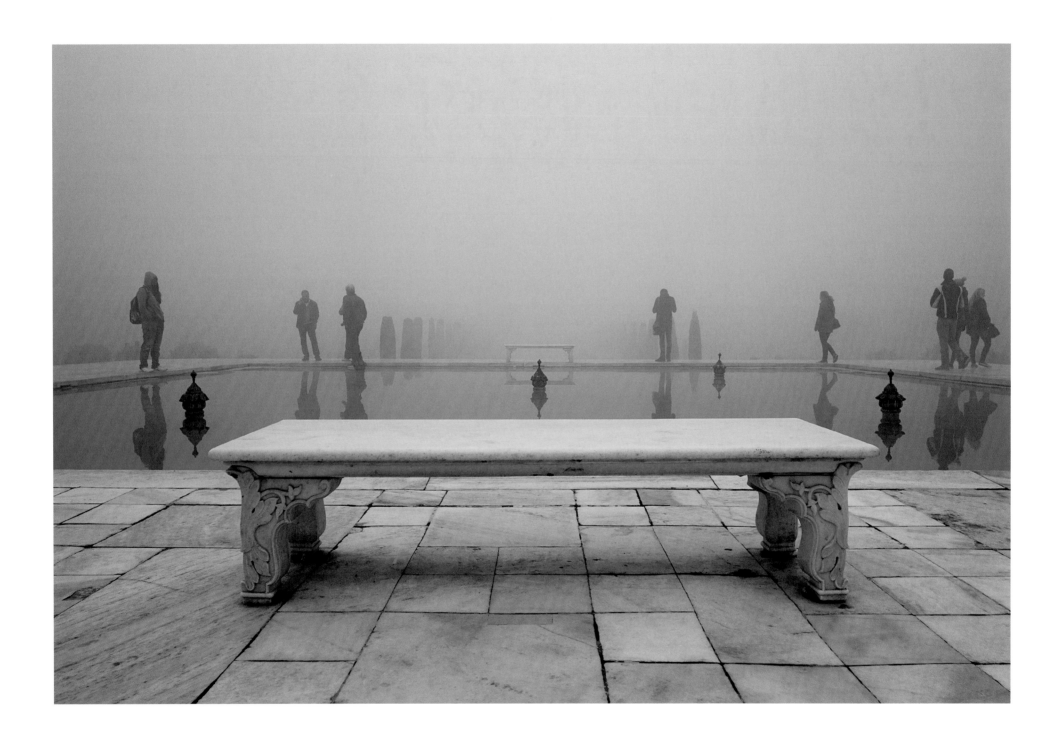

Taj Mahal, Agra, India

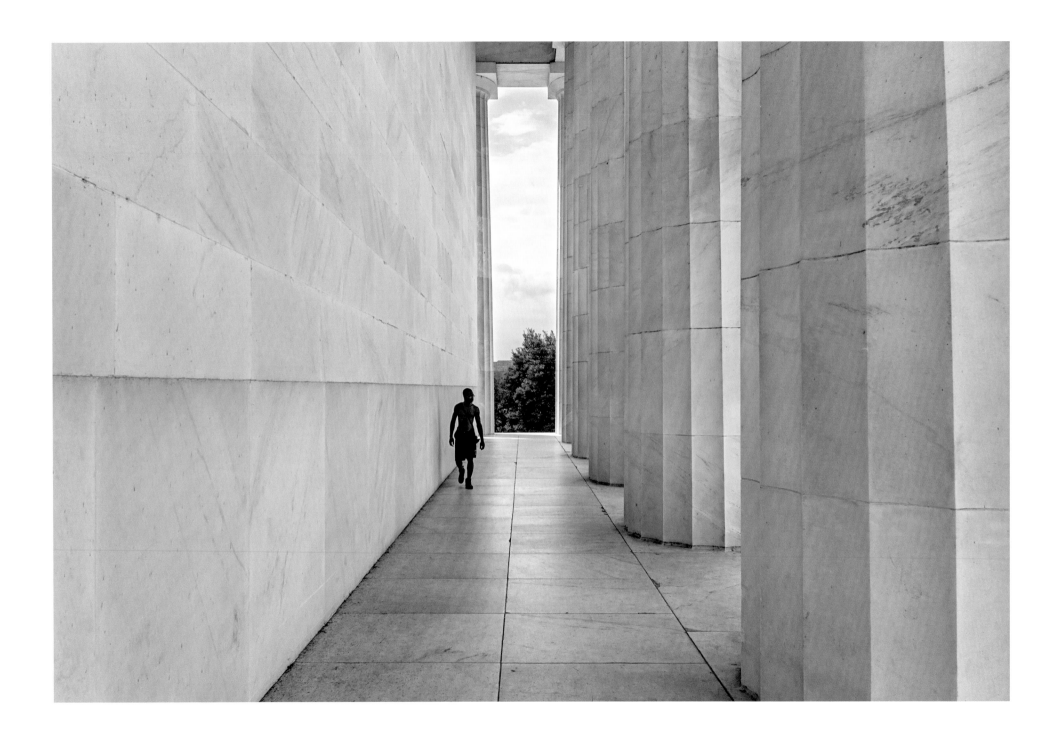

Lincoln Memorial, Washington, D.C., USA

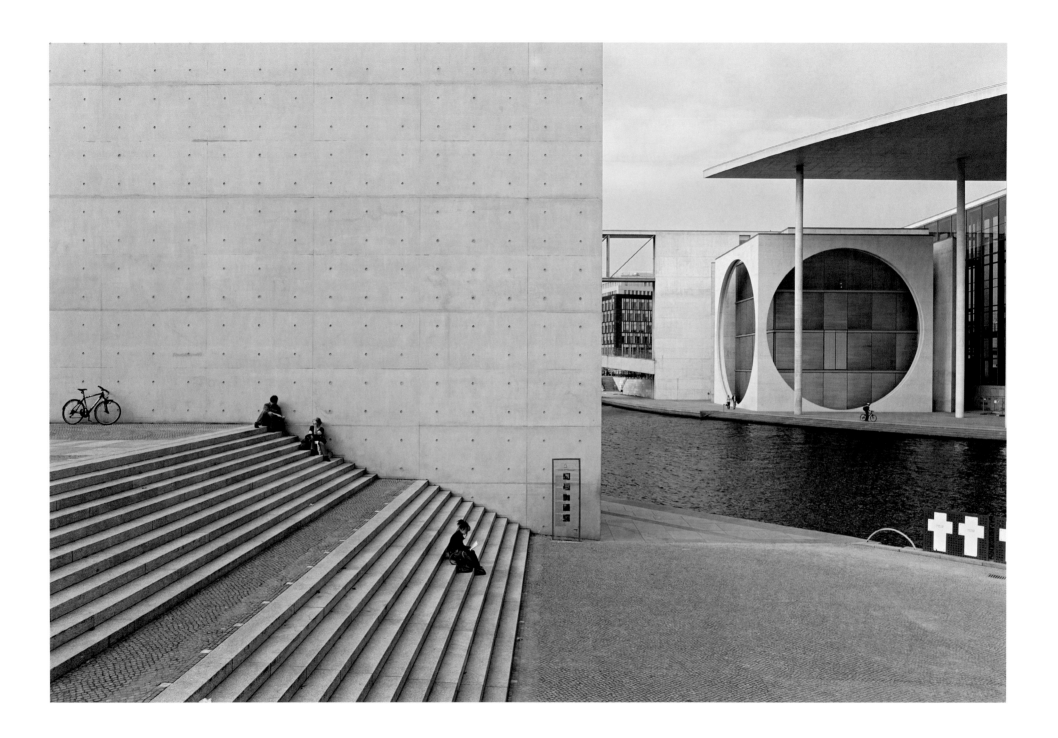

Reichstag, Berlin, Germany

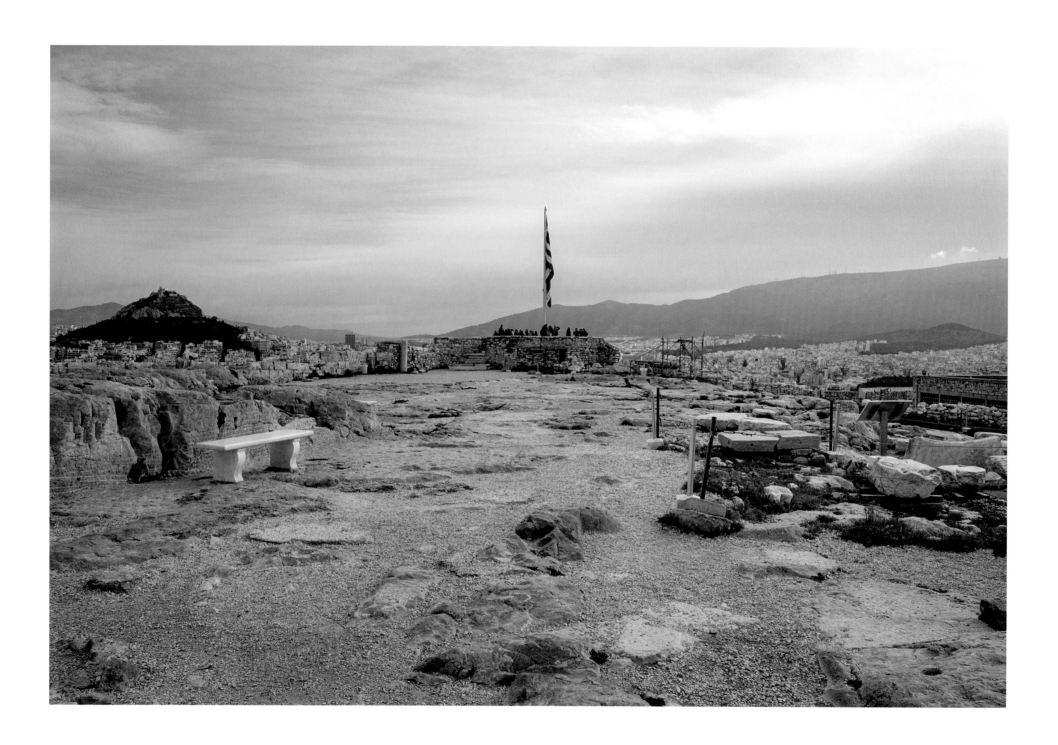

Parthenon, Athens, Greece

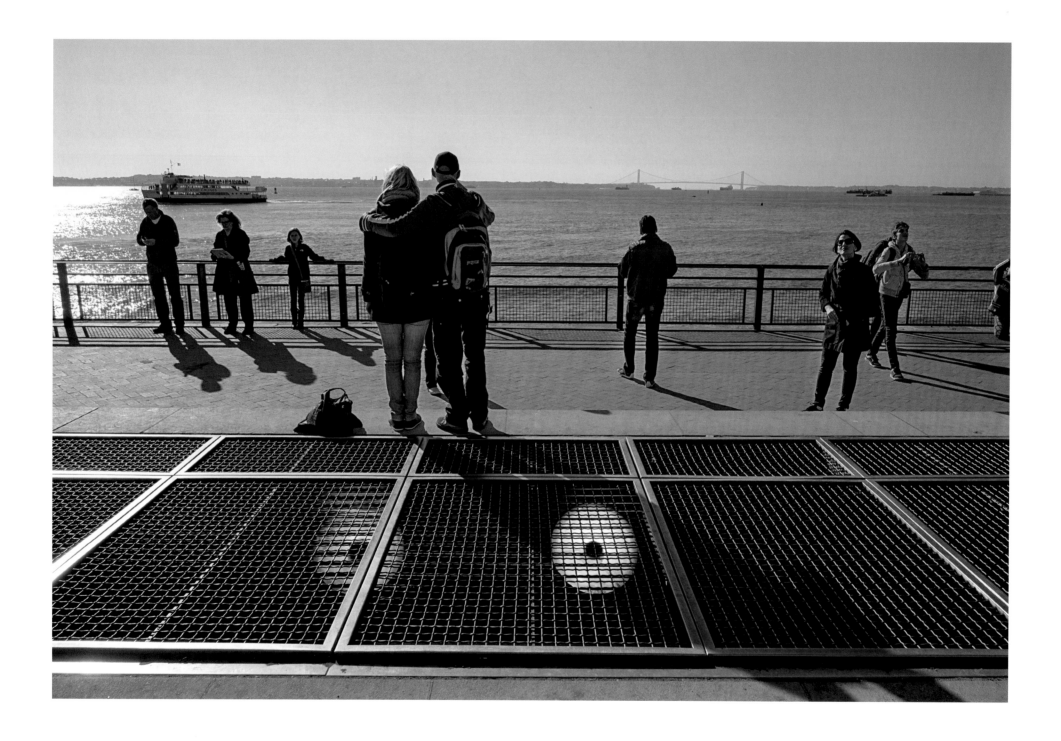

Statue of Liberty, New York, USA

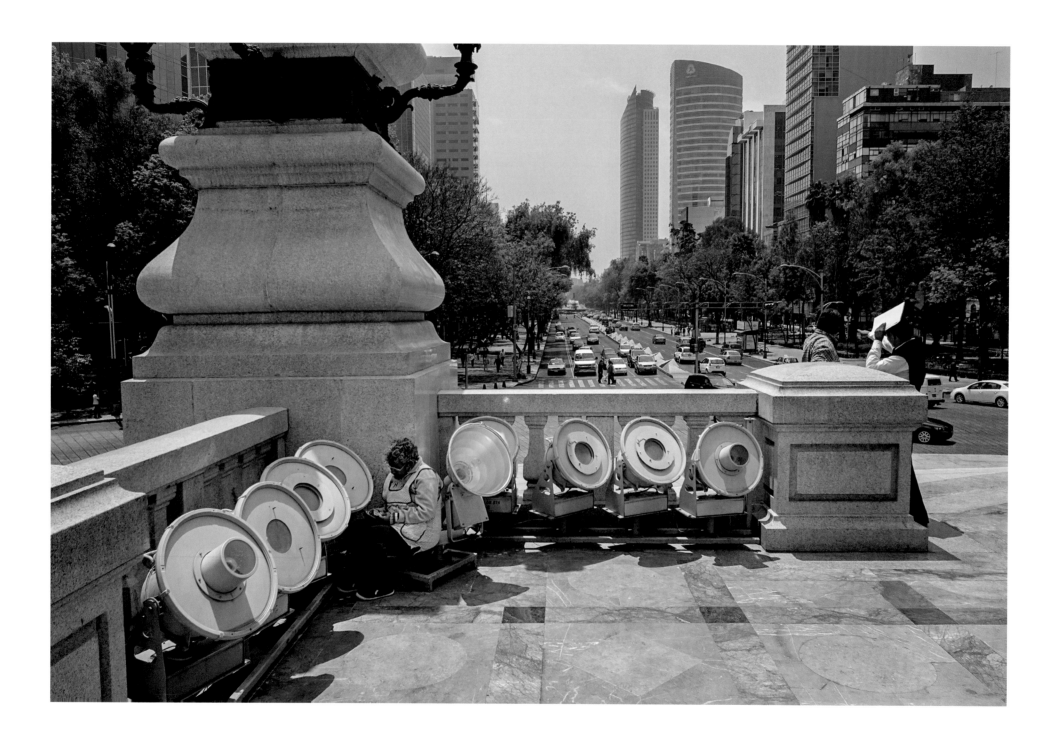

Angel of Independence, Mexico City, Mexico

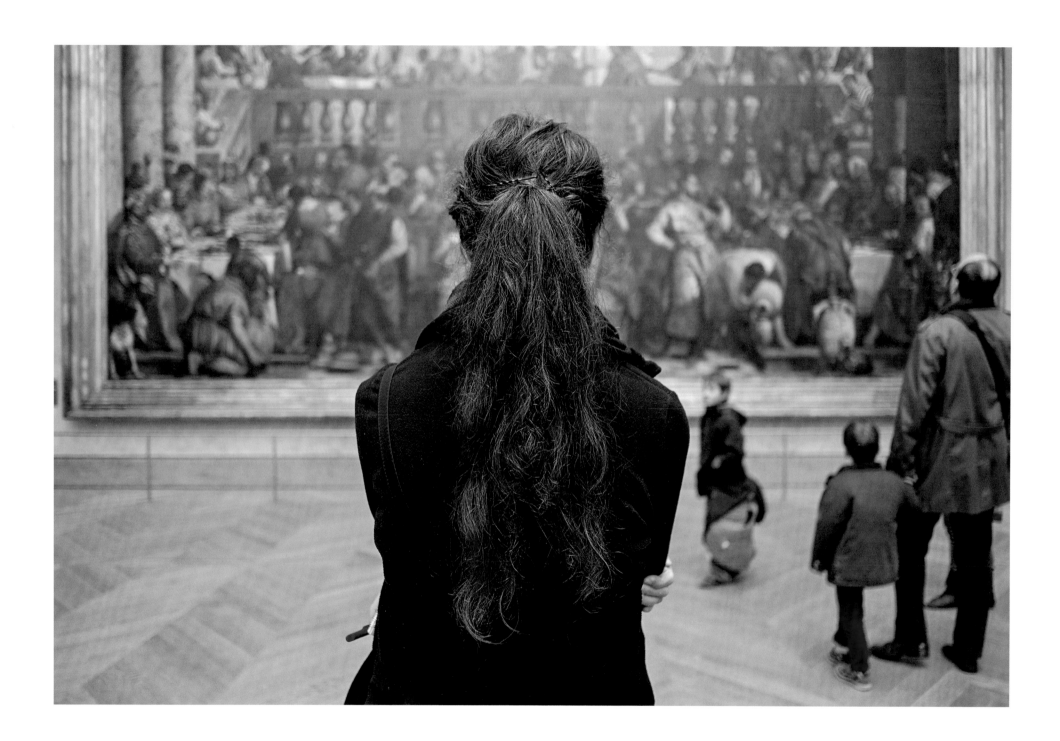

Mona Lisa, Louvre, Paris, France

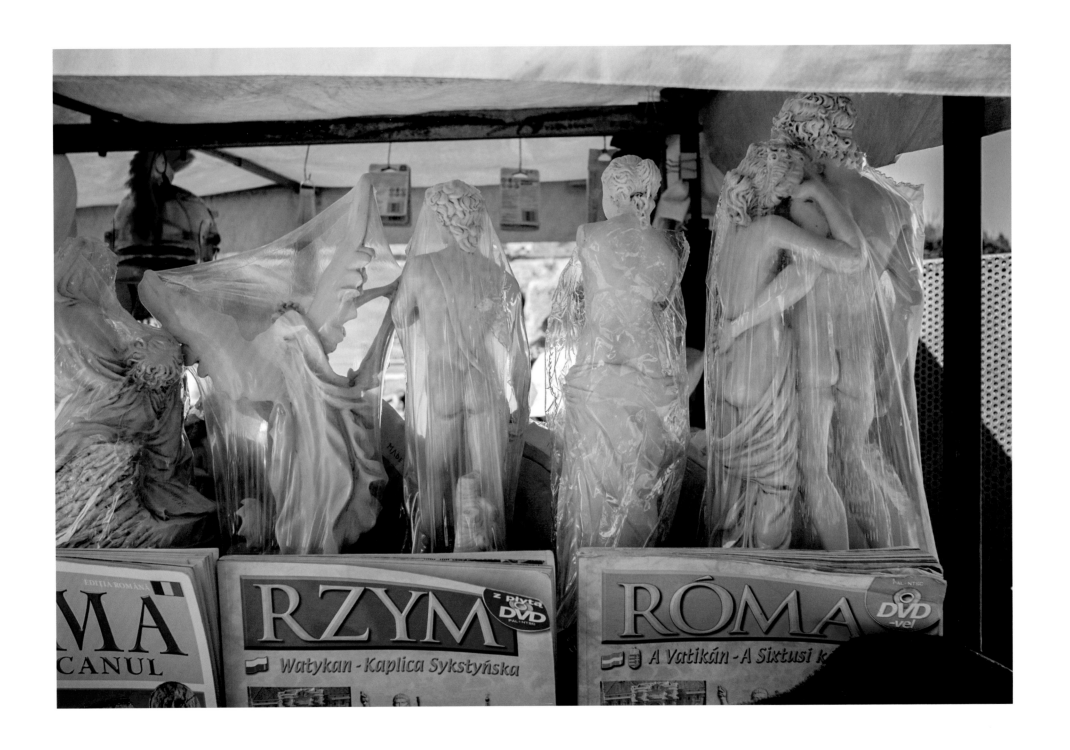

Colosseum, Rome, Italy

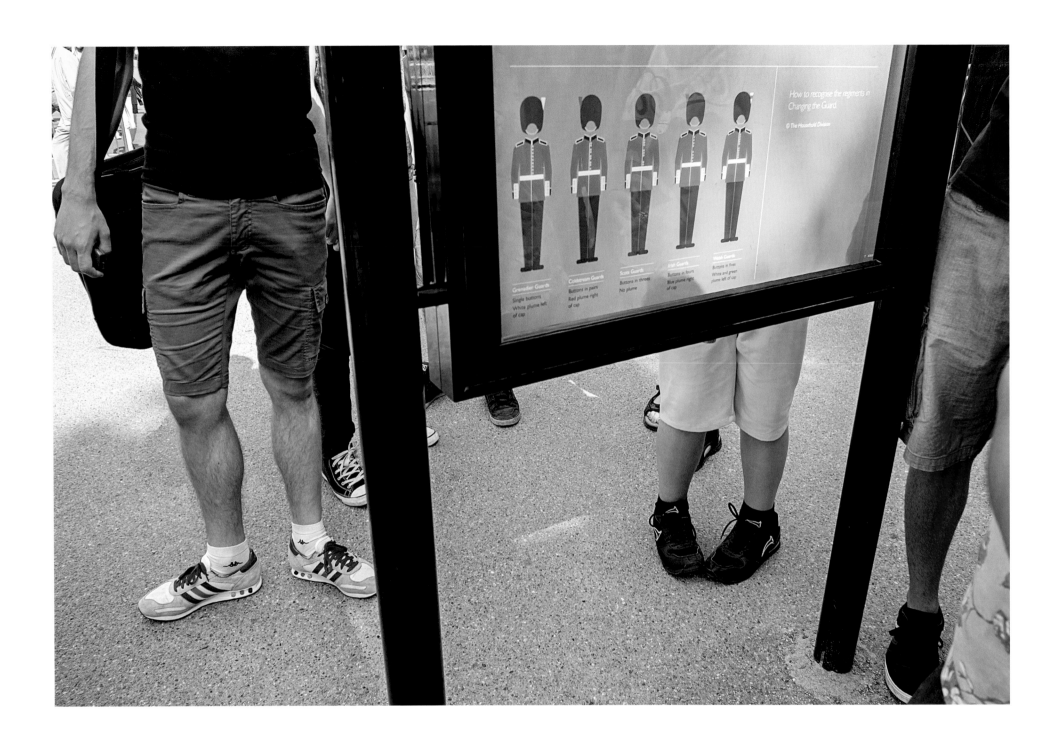

Buckingham Palace, London, UK

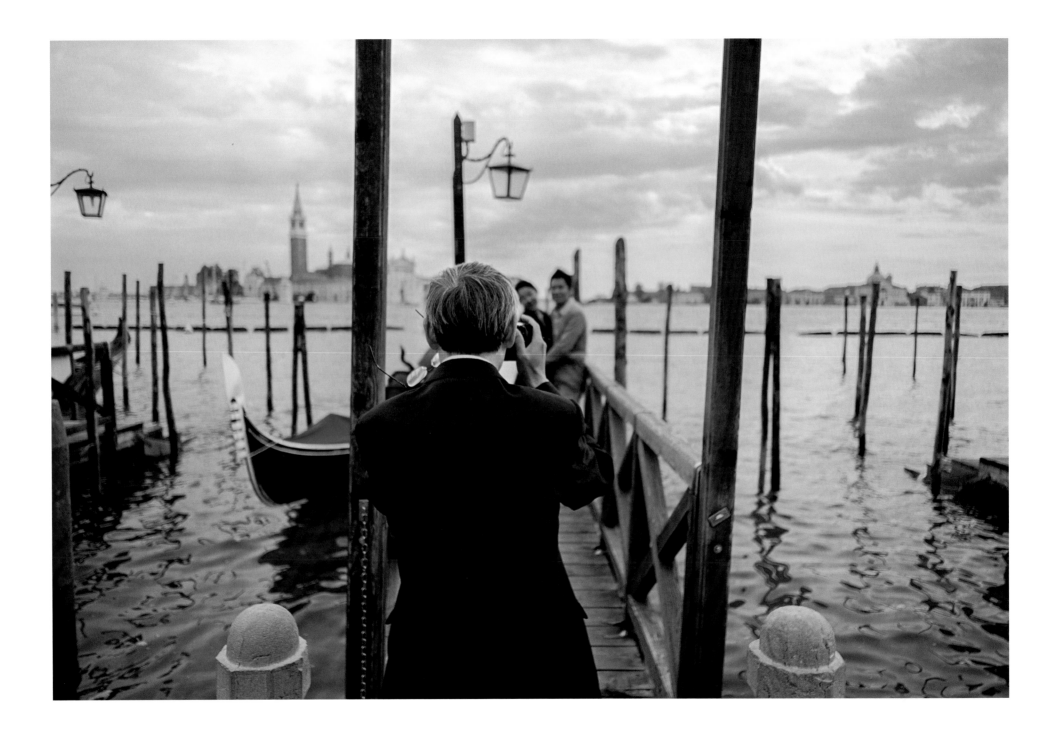

St. Mark's Square, Venice, Italy

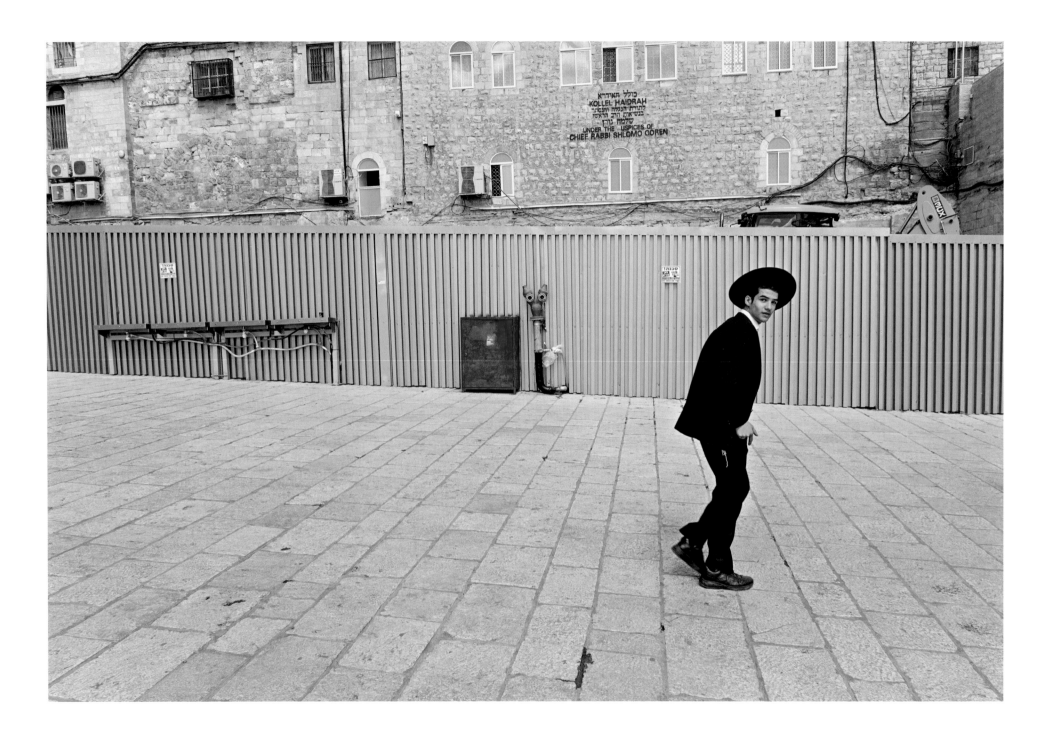

Wailing Wall, Jerusalem, Israel

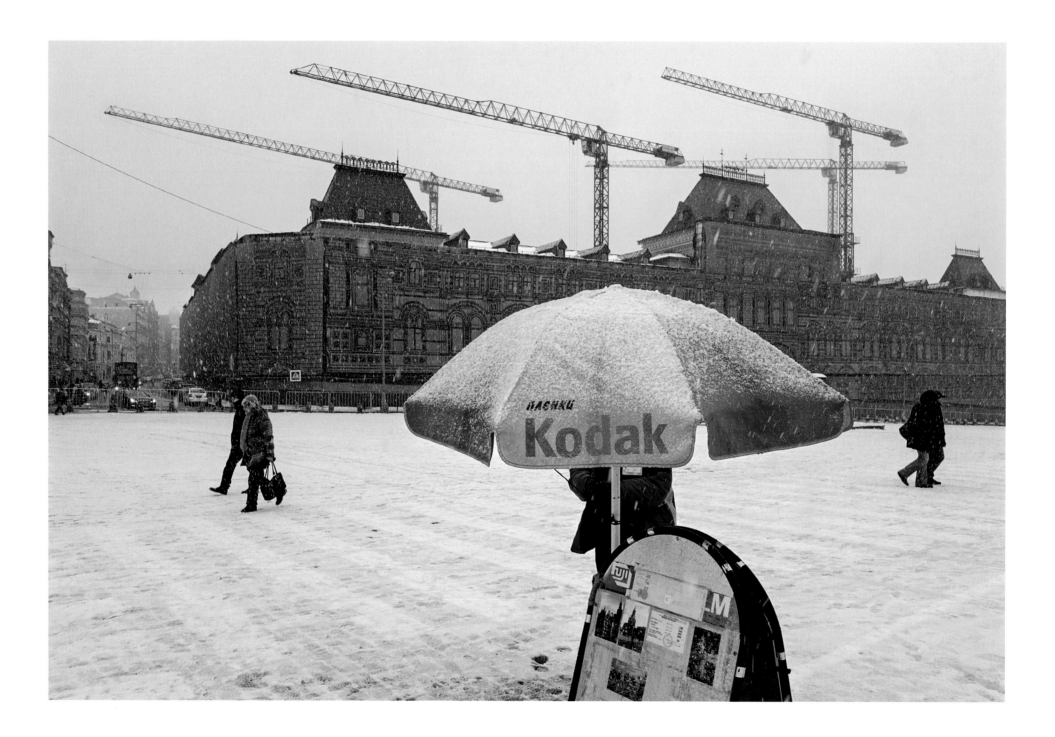

Lenin Mausoleum, Moscow, Russia

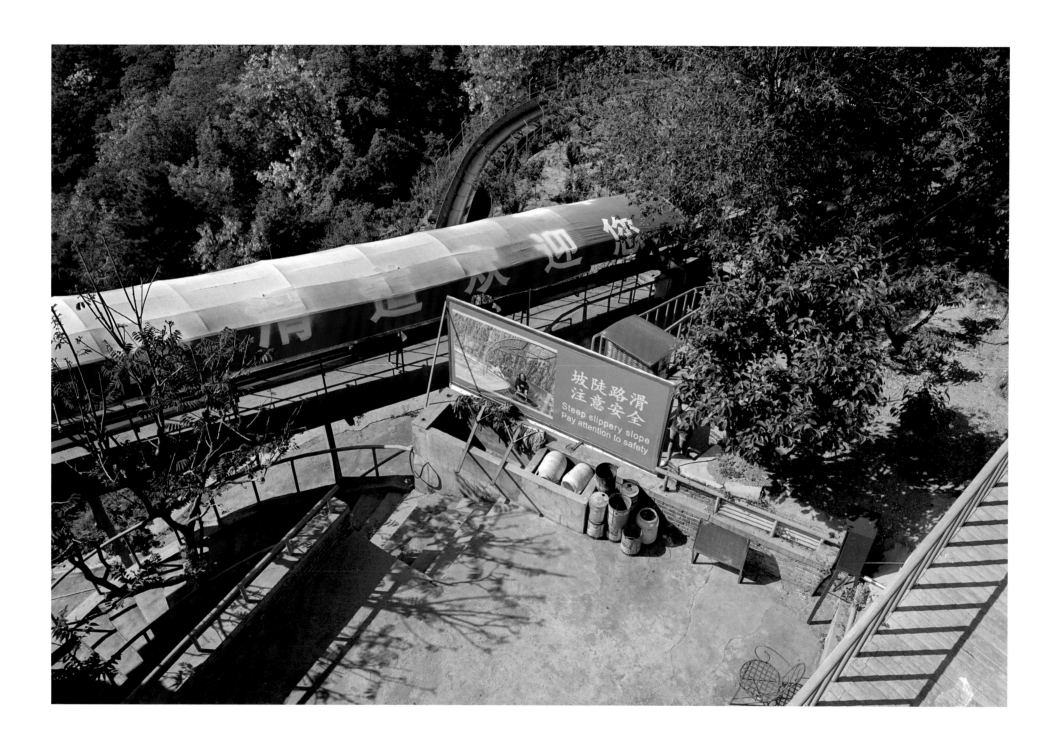

Great Wall of China, Mutianyu, China

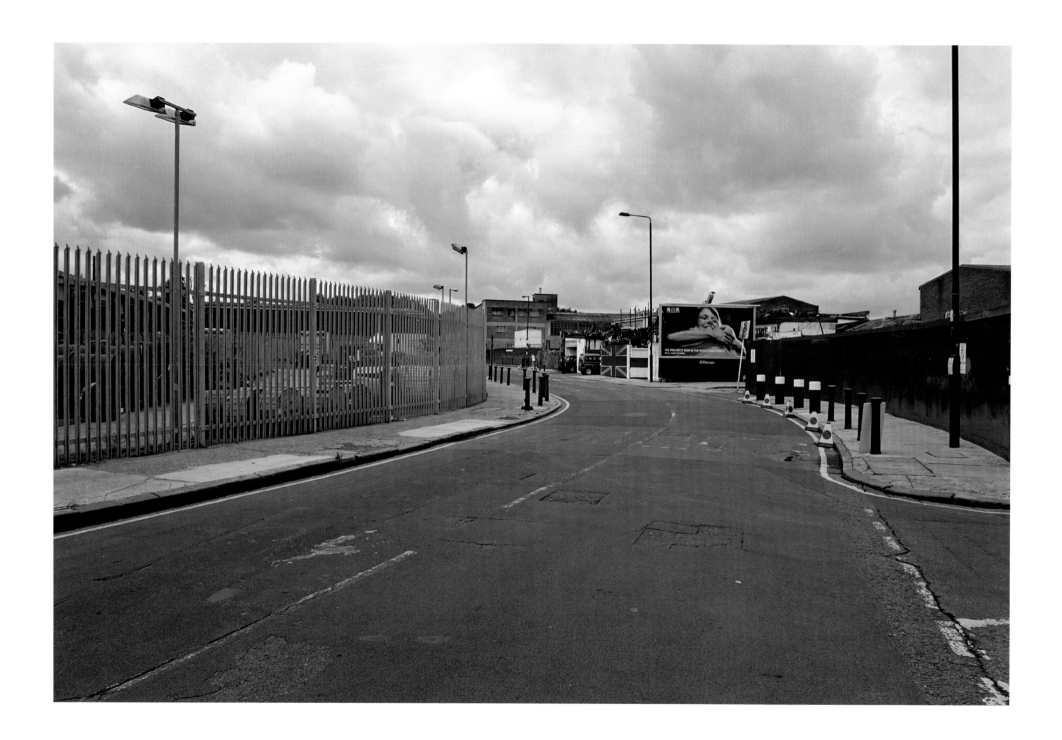

Queen Elizabeth Olympic Stadium, London, UK

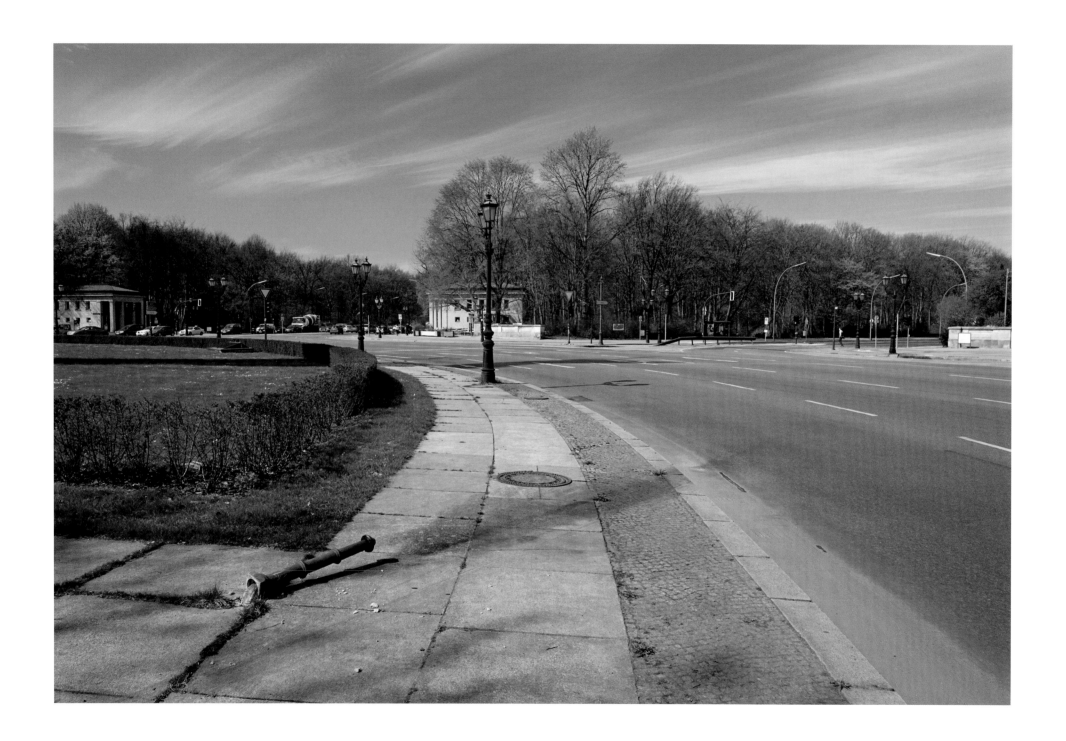

Angel of Victory, Berlin, Germany

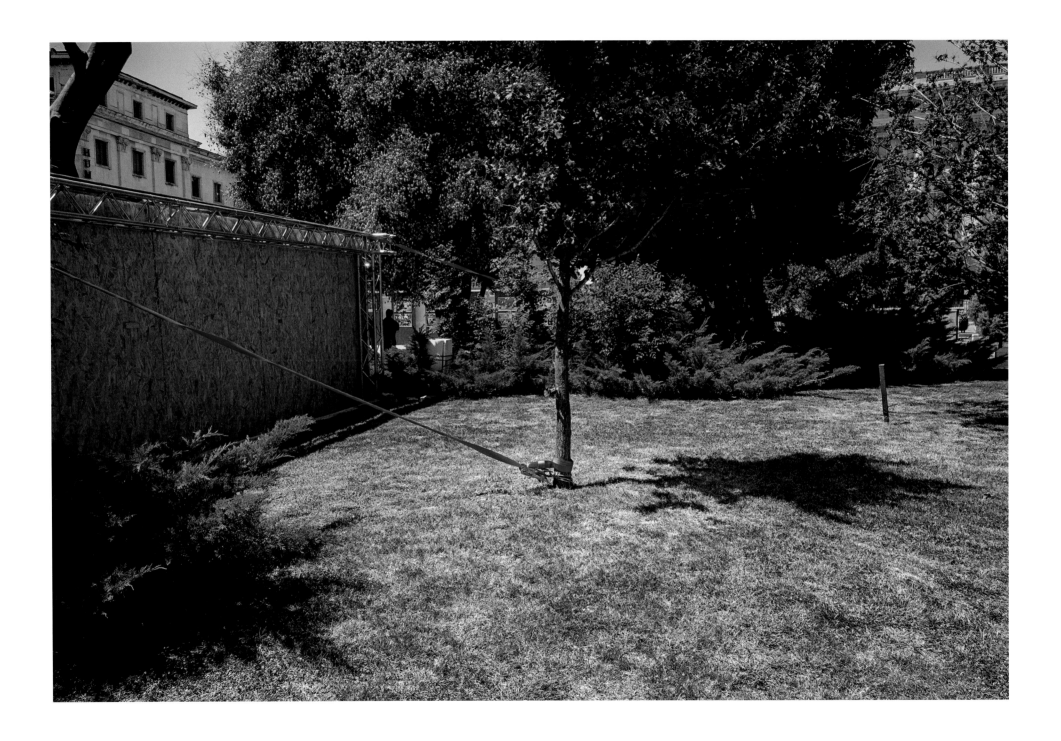

Ministry of Internal Affairs, Revolution Square, Bucharest, Romania

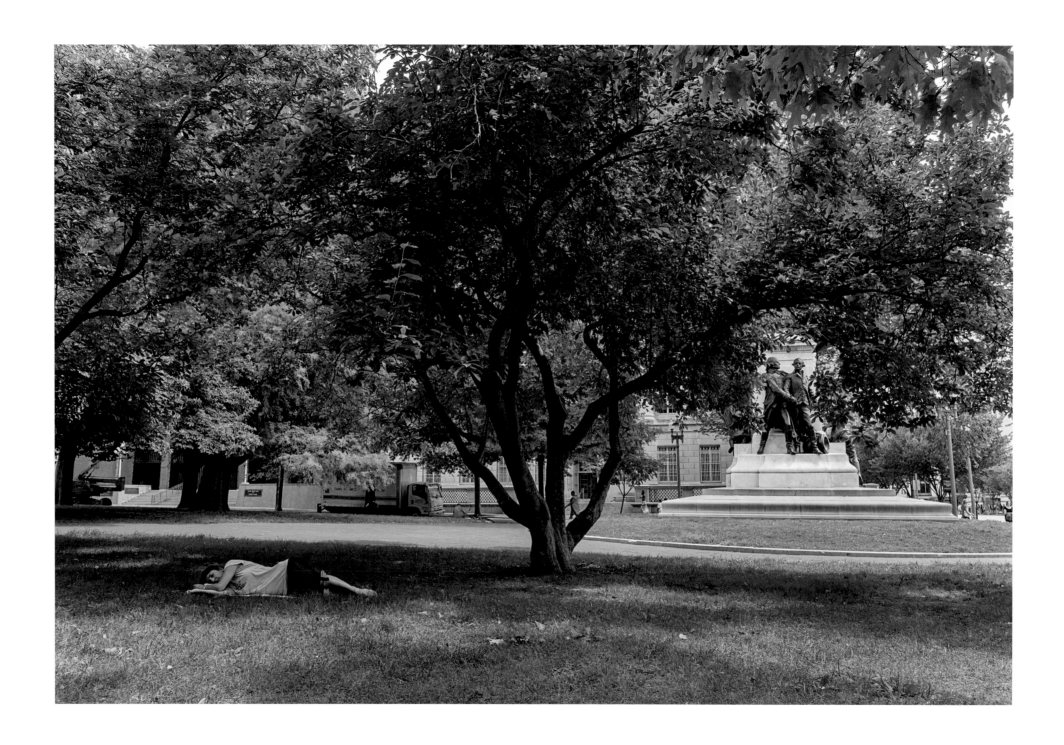

White House, Washington, D.C., USA

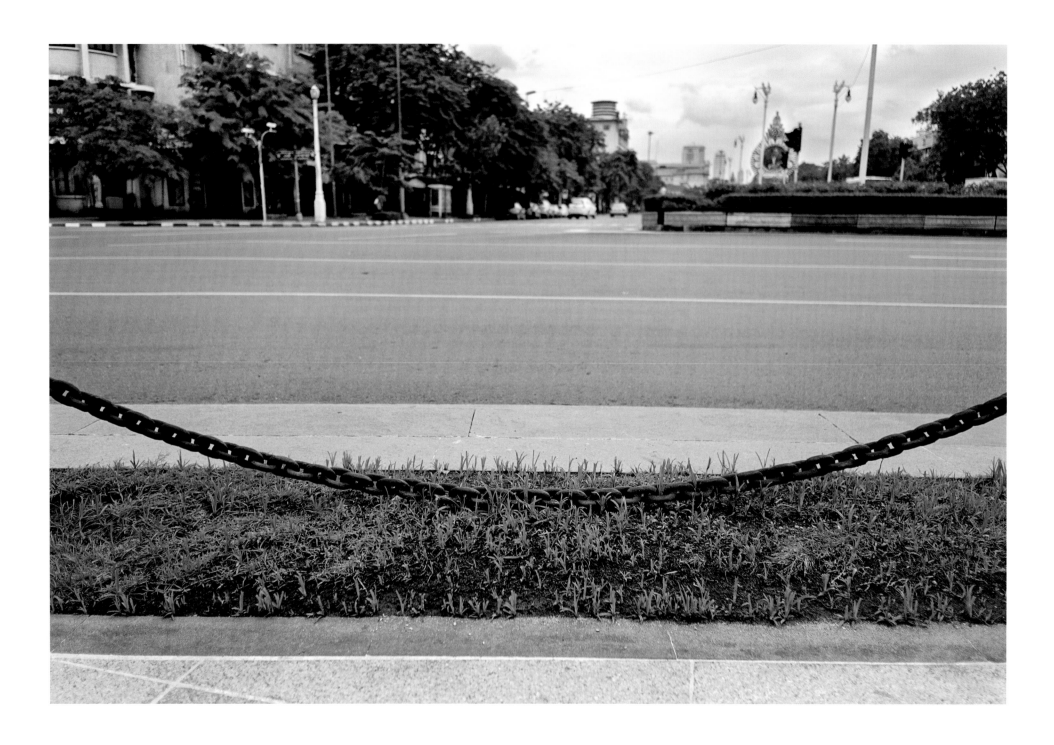

Democracy Monument, Bangkok, Thailand

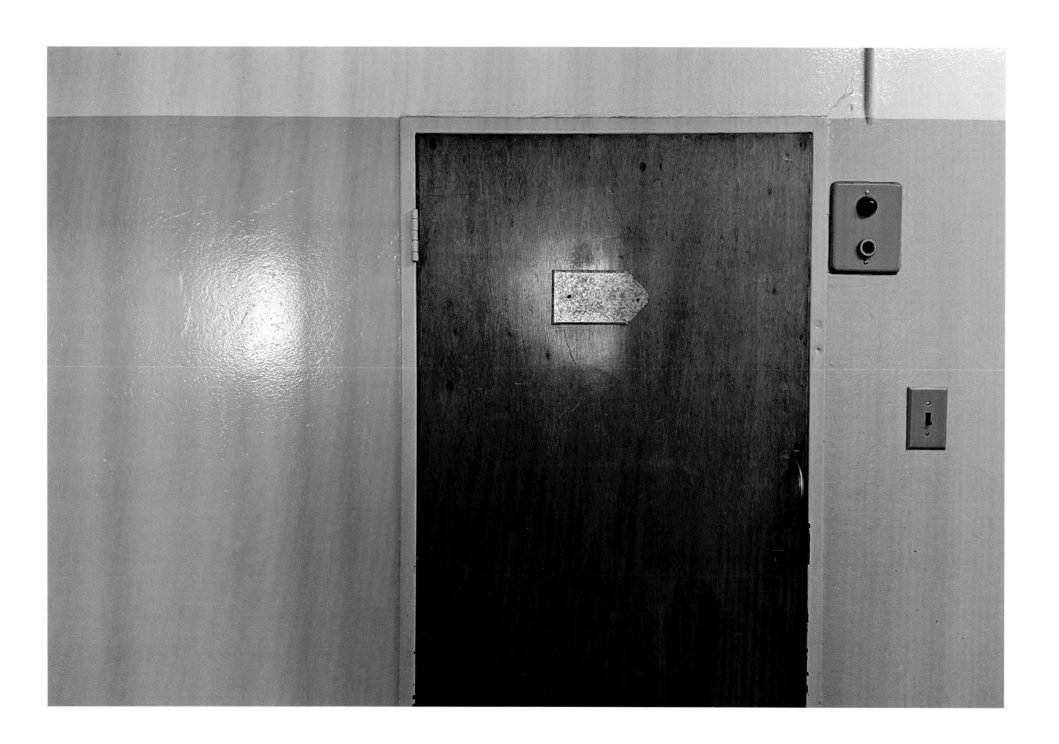

Nelson Mandela's Cell, Robben Island, Cape Town, South Africa

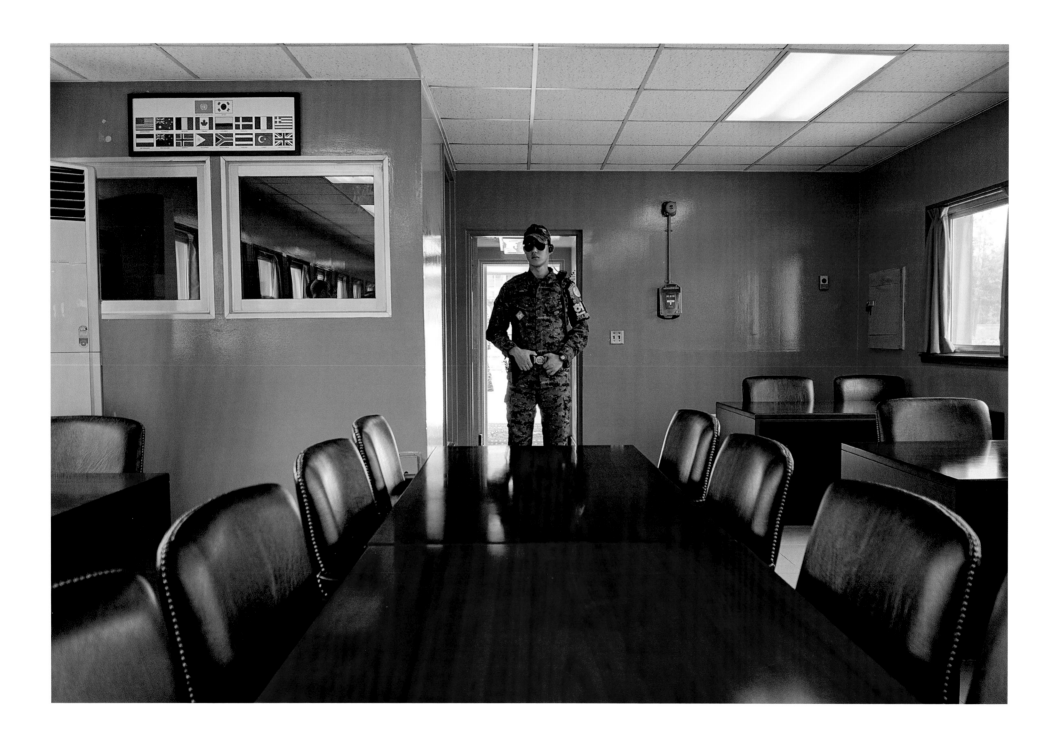

North Korean Panmunjeom DMZ, JSA, Korea

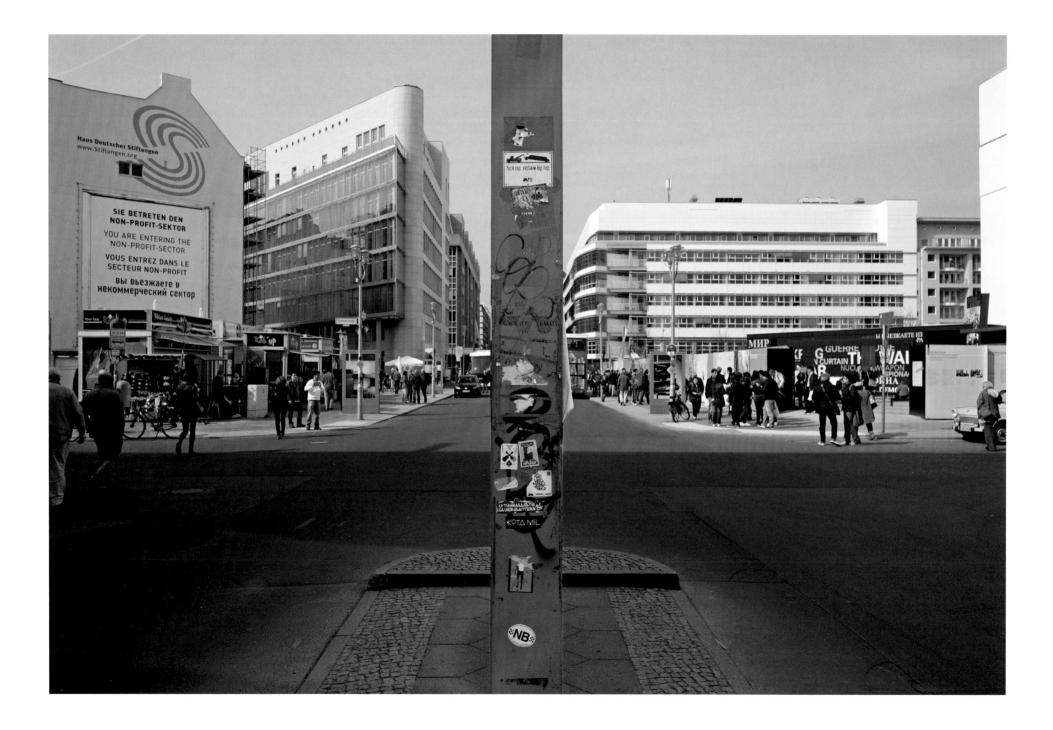

Checkpoint Charlie, Berlin, Germany

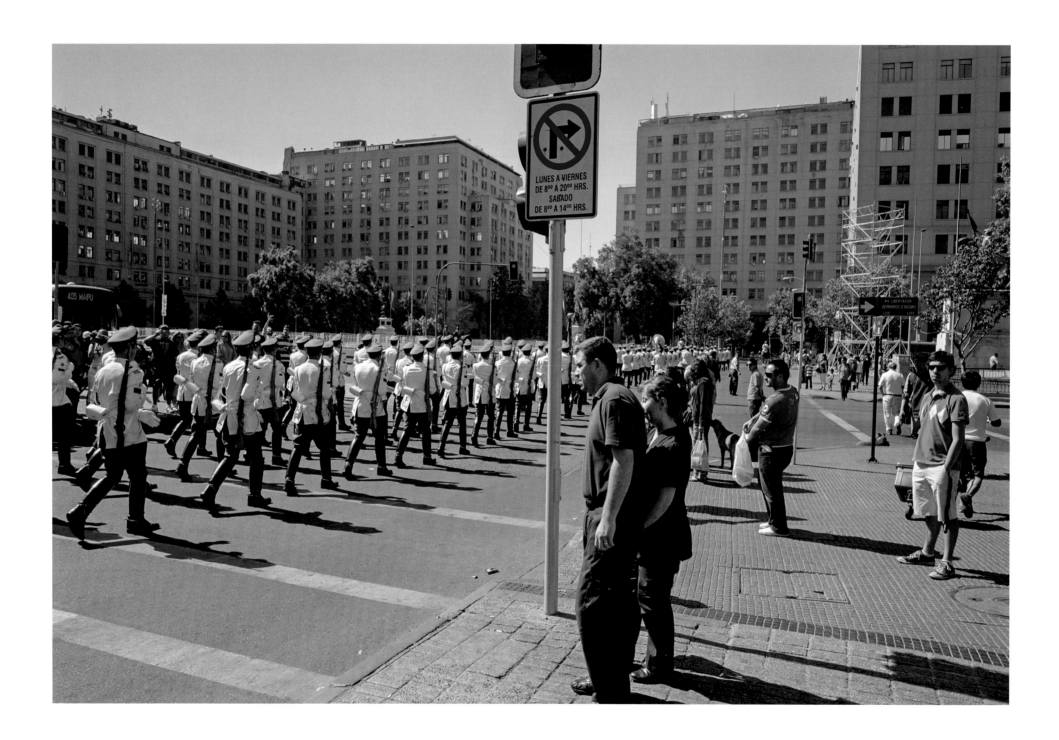

La Moneda Palace, Santiago, Chile

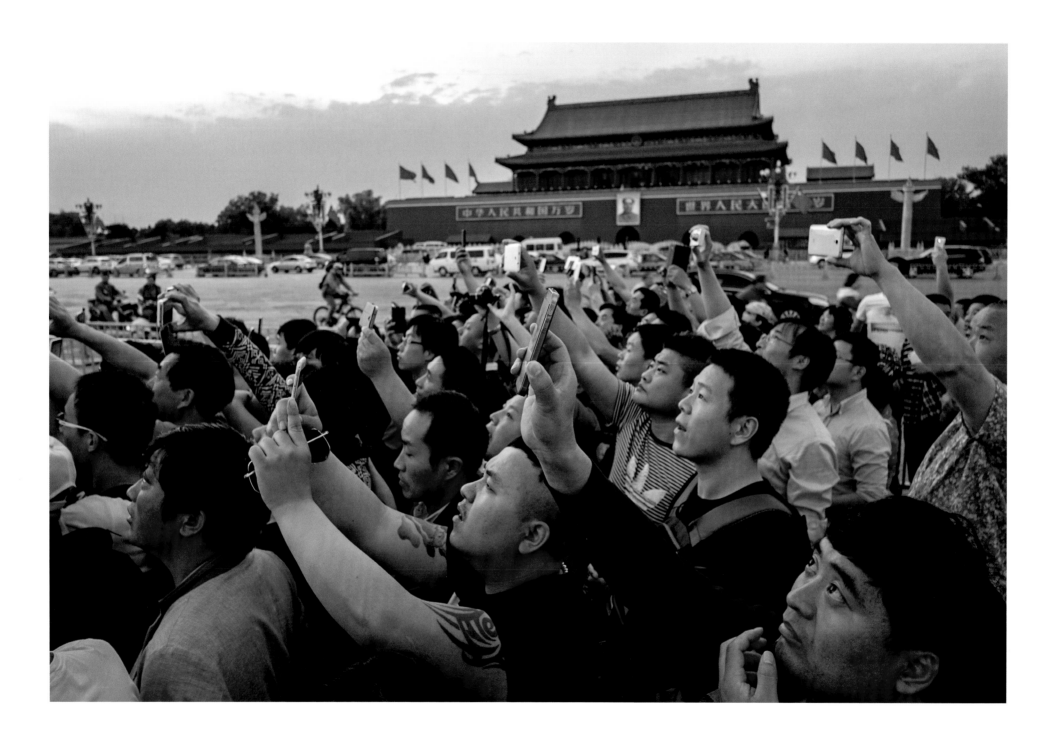

Mao Mausoleum, Tiananmen Square, Beijing, China

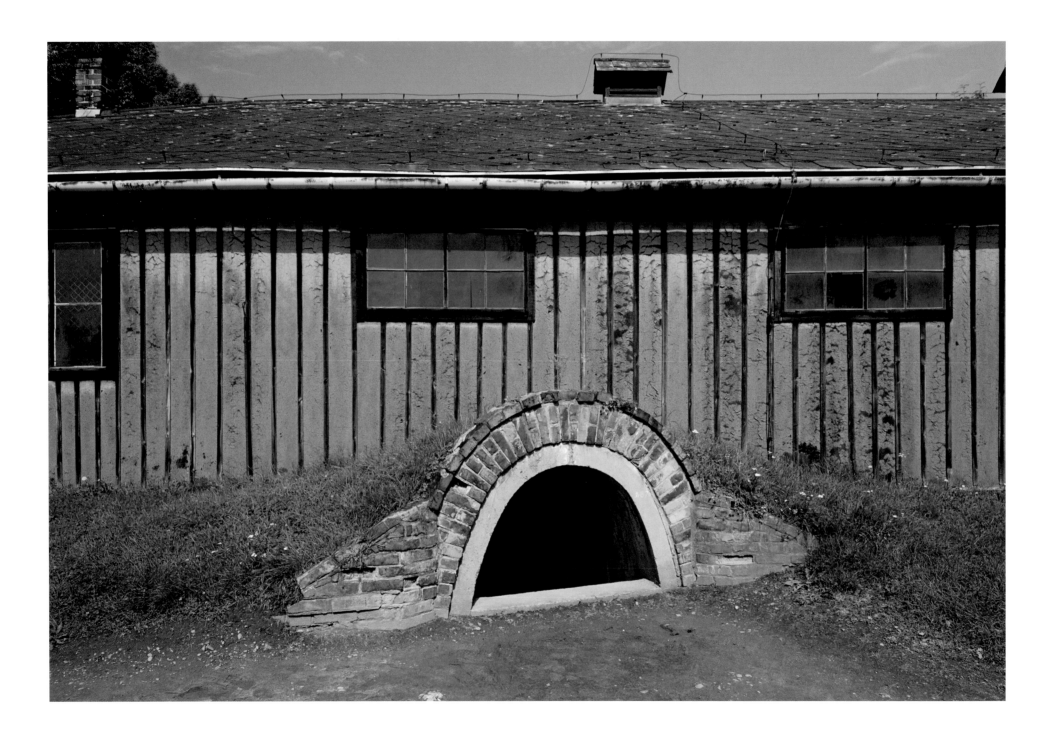

Auschwitz, Oświeçim, Poland

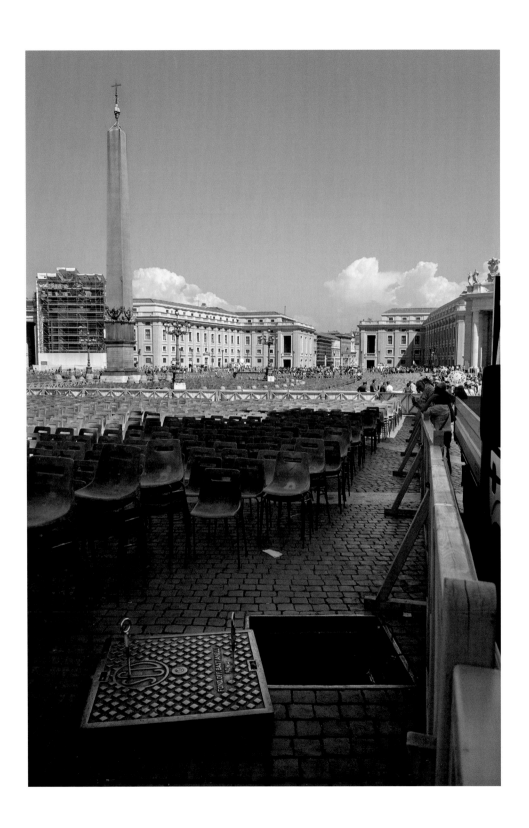

St. Peter's Basilica, Piazza San Pietro, Vatican City

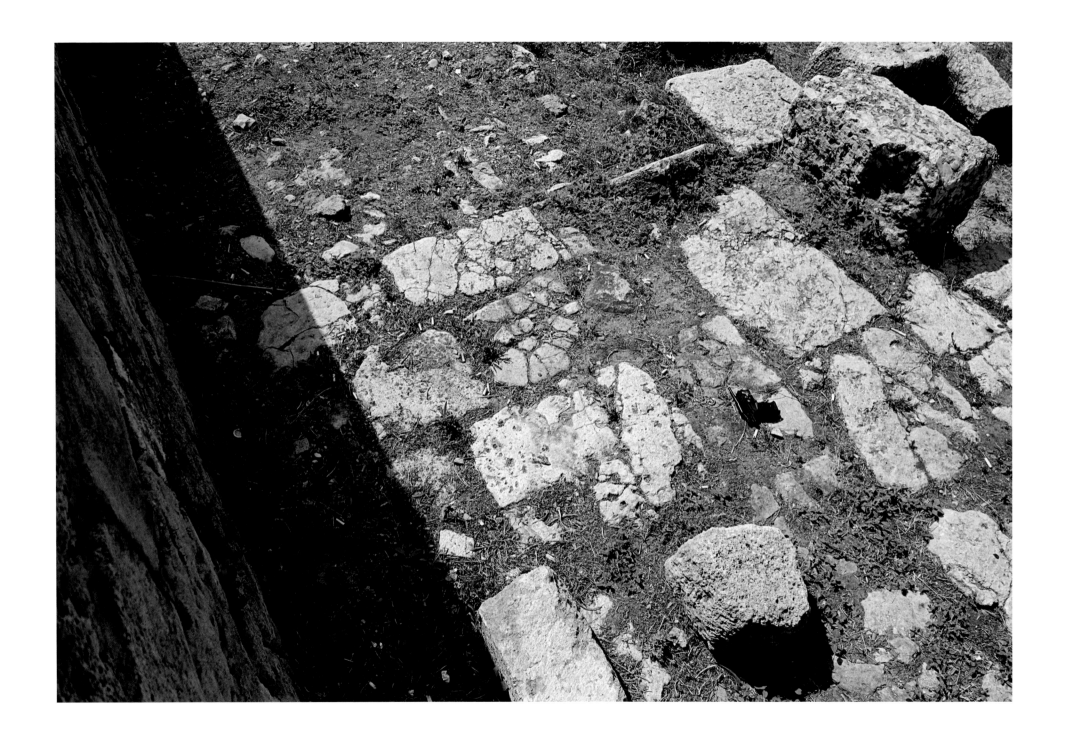

Crusader Castle, Byblos, Lebanon

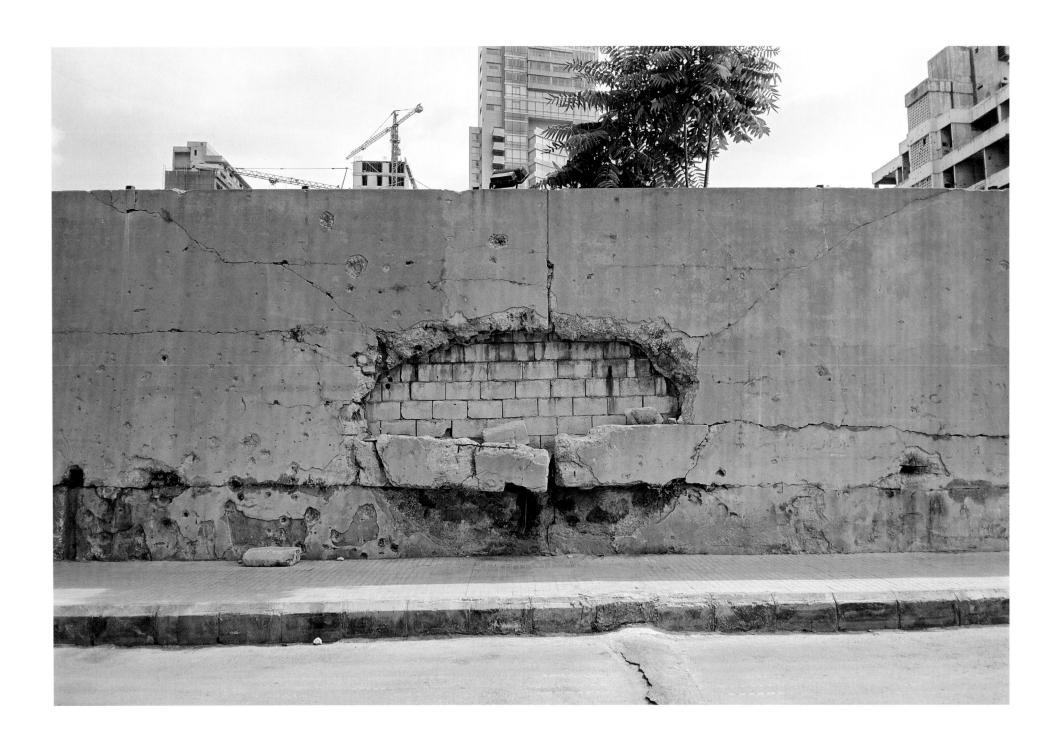

Holiday Inn, Beirut, Lebanon

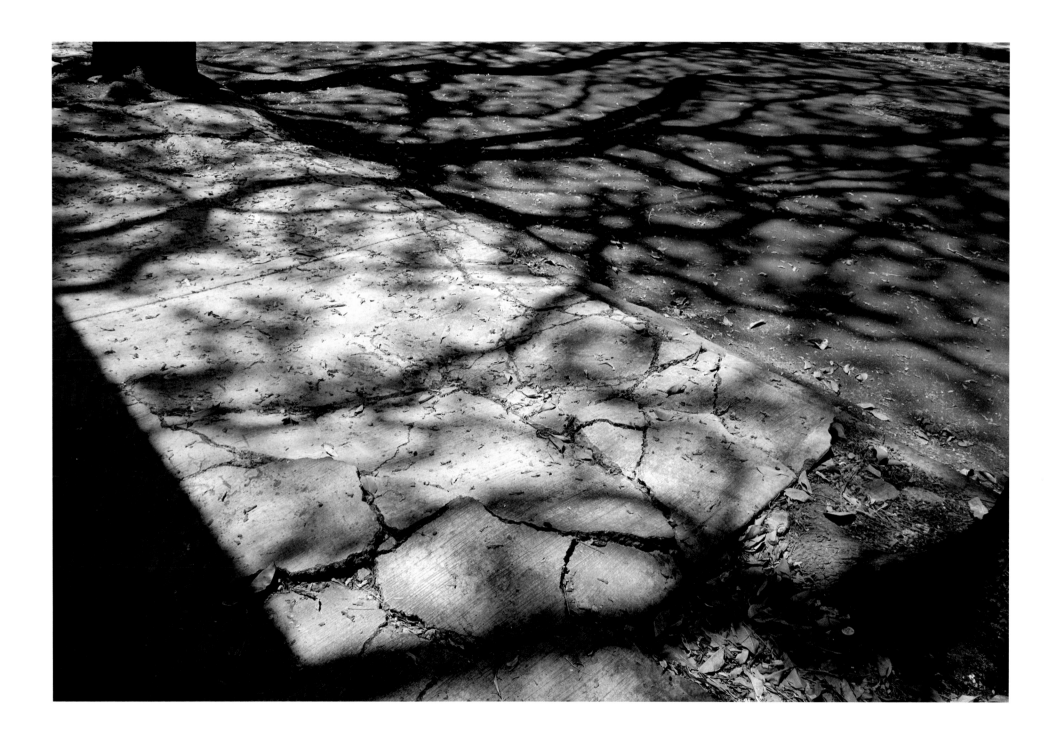

Frida Kahlo Museum, Coyoacan, Mexico

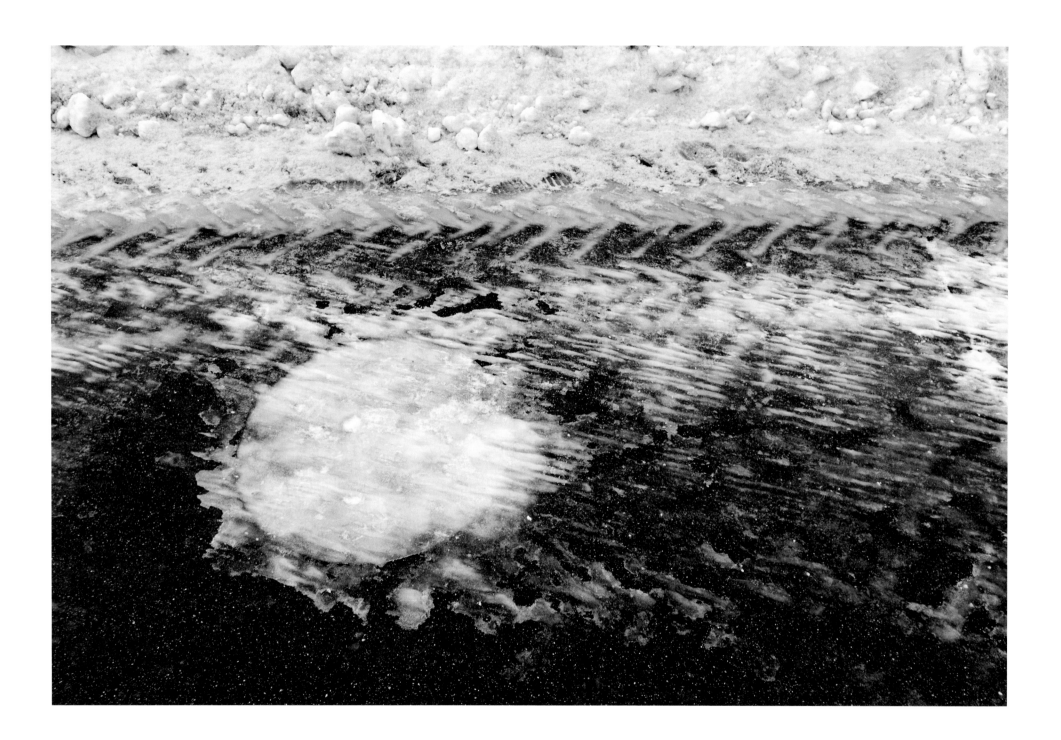

Kremlin, Moscow, Russia

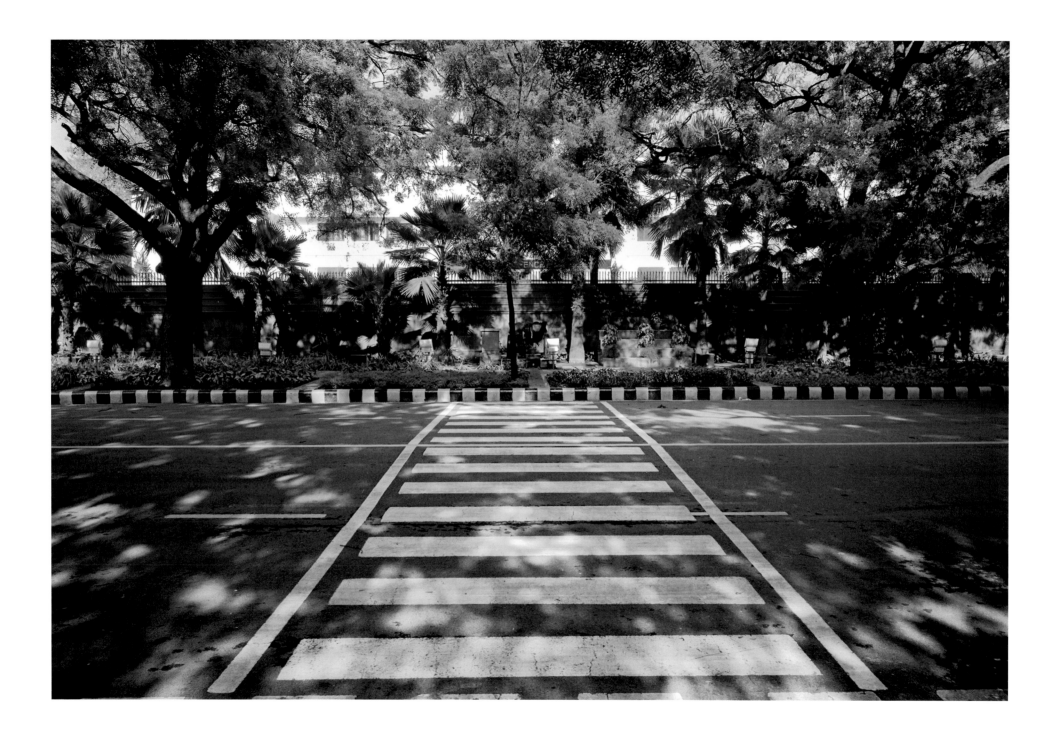

Gandhi Smriti, New Delhi, India

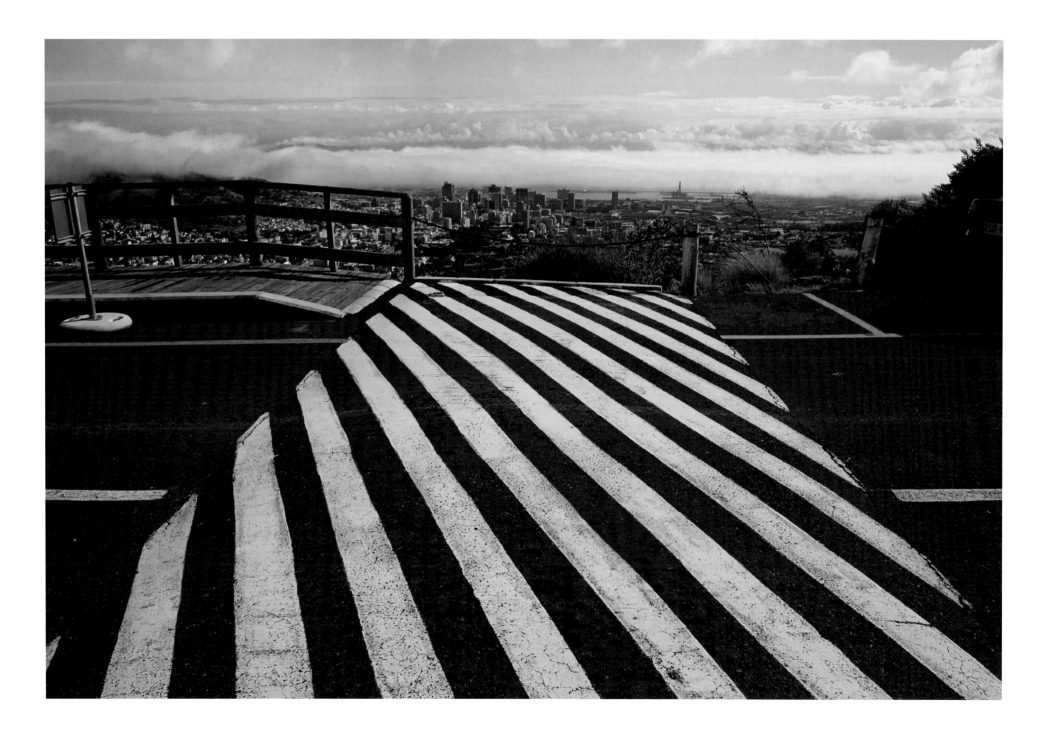

Table Mountain, Cape Town, South Africa

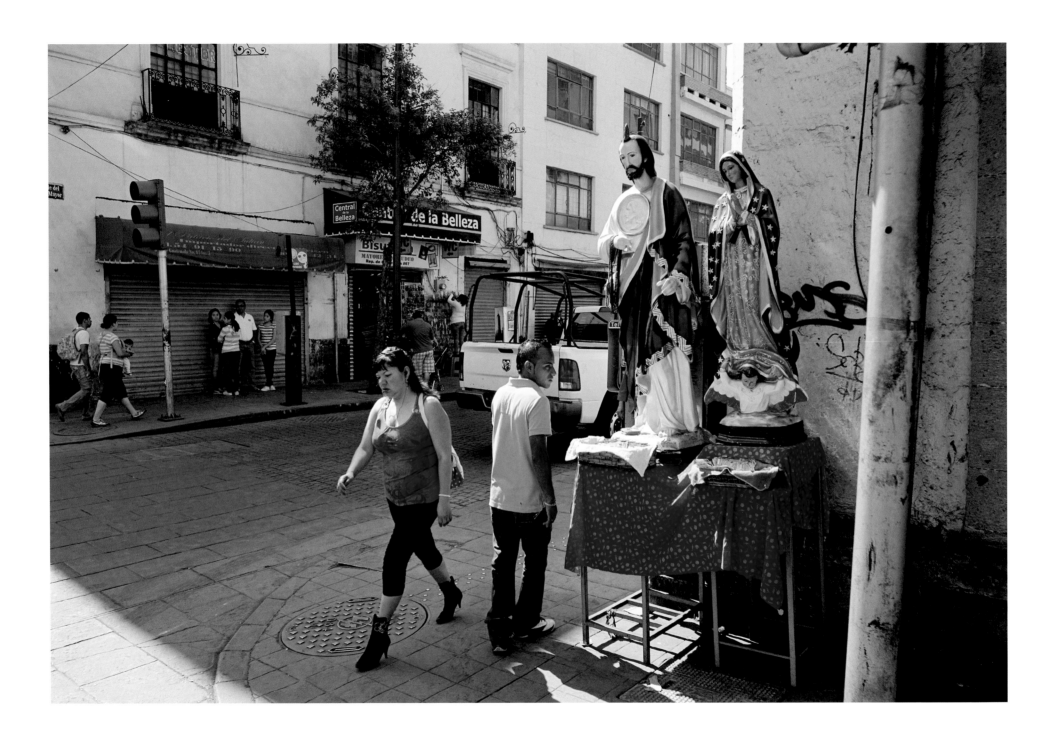

Templo Mayor, Mexico City, Mexico

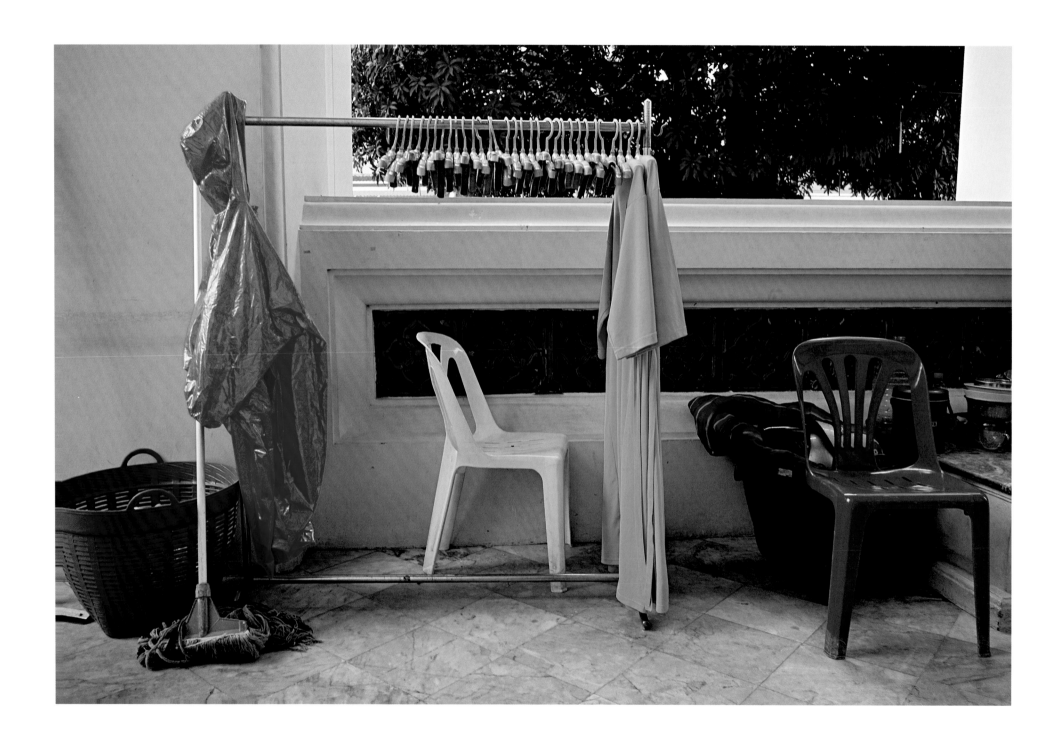

Wat Poh, Bangkok, Thailand

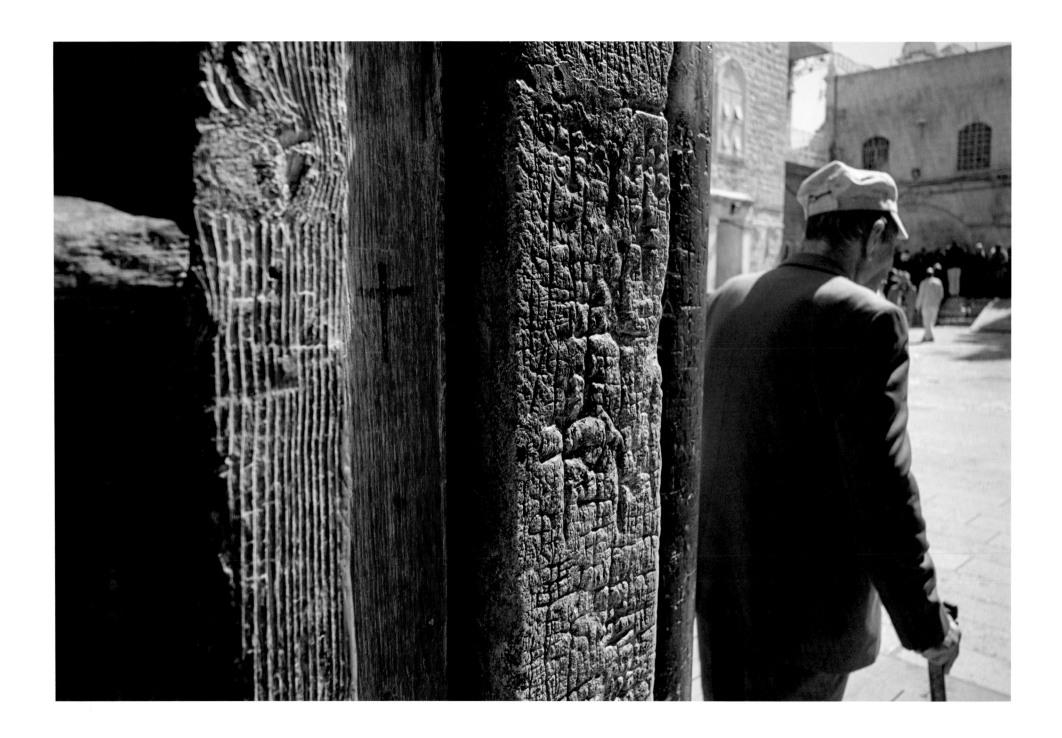

Church of the Holy Sepulchre, Jerusalem, Israel

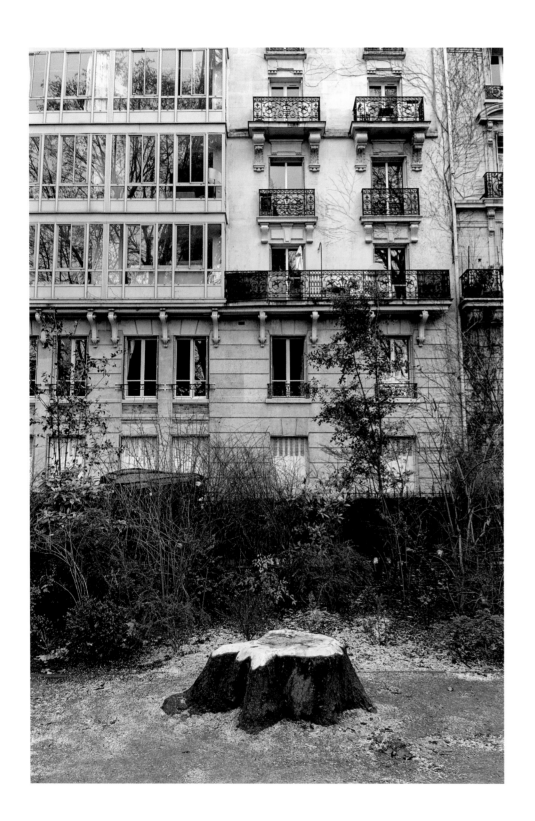

Eiffel Tower, Paris, France

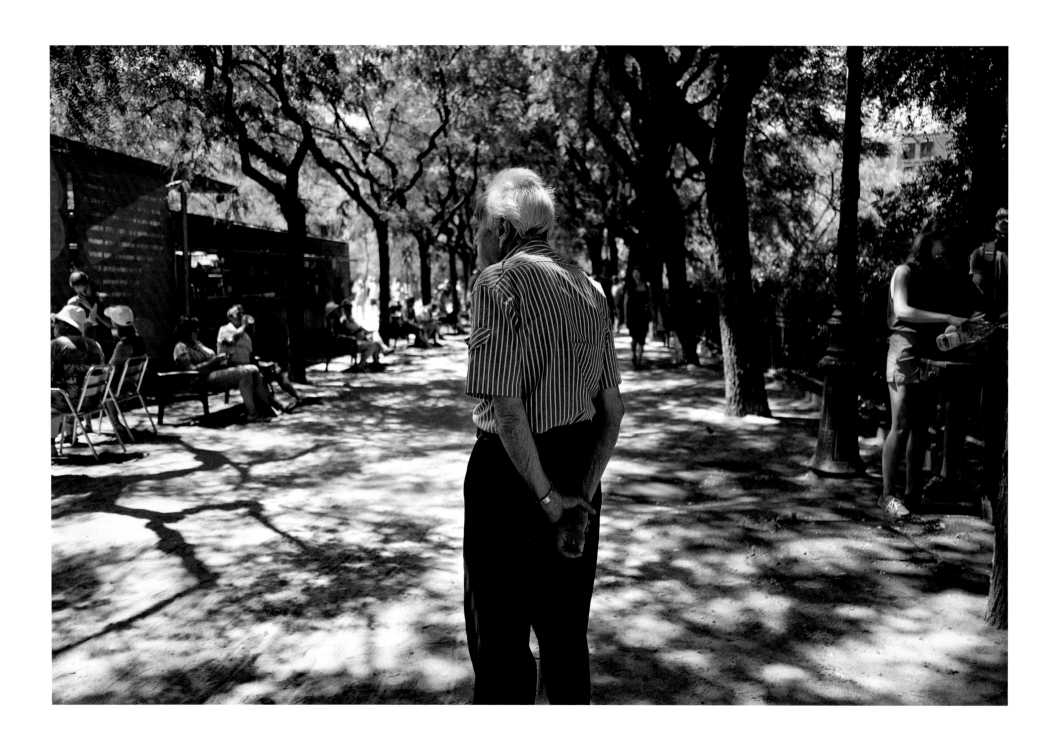

Sagrada Familia, Barcelona, Spain

World Trade Centre (South Tower site), New York, USA

ABOUT-FACE

A simple idea that raises interesting questions and leads to aesthetically successful results: show up at some of the world's most visited – and therefore photographed – monuments and sites, turn your back on the very thing you have come to see, and record the view that no-one else is interested in. It's not the same as photographing a famous site from an unexpected angle – from behind the HOLLYWOOD sign, as Robert Frank did in the 1950s – in order to reveal its local or grubby underside. Often, in Oliver Curtis's *Volte-face*, the monuments do not even get a look in. What we get, instead, is an idea of what they look at.

In films a character's point of view is often conveyed by showing that character from behind while looking over his or her shoulder. Without this bodily reminder we would see without knowing who was doing the seeing. Once the viewpoint has been fixed – once we have entered the mind of the looker – these glimpses of the consciousness-bearing body can be dispensed with as the film unfolds over time. But what of a photograph which isolates and is stuck in a single instant of time? A picture by the Danish photographer Per Bak Jensen shows a statue, seen from behind and slightly to one side. But it also conveys what it is like to be that statue, to be confronted with the same view, day after day, year after year. Without the statue the picture would offer a relatively uninteresting view of landscape. By framing the picture as he does, Jensen introduces the idea – or, even better, induces the feeling – of unsentient or dormant consciousness.

If we saw a single, uncaptioned picture from *Volte-face* it could appear quite meaningless or pointless. Once we've seen a few, with the locations indicated, we begin to understand what we are looking for in each new picture even if we don't know exactly what we are looking at. Even without recourse to the identifying captions we can try to get our bearings and, if we have visited the place in question, might be able to work out where we are in spite of the absence of the very thing that is where we are. It depends on the place though. Some of the most spectacular places in the world provide a fully immersive experience in that they offer abundant views of themselves from themselves. Angkor Wat, for example, is a superb place from which to see Angkor Wat. Perhaps that's why, in these pages, it is no-where to be seen. Sometimes the site offers a view of somewhere less famous, less historically freighted with meaning, but still quite pleasing, as happens in the view from St. Mark's Square in Venice. Elsewhere we are confronted, in exalted form, with what might be called the non-reciprocity of real estate. A house is on the market for a price well in excess of two million pounds: a fabulous place with gorgeous rooms, perfectly designed and maintained exterior and enormous windows. These windows afford unobstructed views of the building opposite: a social housing block, covered in satellite dishes, entirely functional, done on the cheap and devoid of any visually pleasing features. The rooms are small and the ceilings low but it has one great thing going for it: the windows, though small, are filled with the sight of the splendid house opposite. With their views from – but not of – sites of world-heritage splendour these photographs take the side of the large house described in that vernacular dilemma or relationship. That they are

about looking is slyly suggested by the way that quite a few of them seem to contain a symbolic eye – or pair of eyes – that returns our gaze. Once we notice the staring floodlights under the grating at the Statue of Liberty gazing at us, wide-eyed, then the circles formed by other techno-logical or architectural features double as a discreet chorus of passively inquisitive eyes. Look at that cartoonish fire hydrant (if that is indeed what it is) with eyes and ears cheekily eavesdropping on the Wailing Wall from its perch by the steel fence. Then there are all those windows – etymologically 'wind-eyes' – offering their own form of blank surveillance. But mainly, of course, it's people who are looking.

In their way the destinations in *Volte-face* are monu-mental equivalents of Sylvia Plath's 'Mirror' ('Most of the time I meditate on the opposite wall') but instead of a solitary viewer occasionally coming into view they are each day treated to an international cast of thousands turning up to relieve the long monotony of time. Often the view includes a road leading out of shot, back into the city from which these pilgrims and visitors have trudged and swarmed. They come to see, to pay their respects and to make and take souvenirs of their seeing in the form of photographs. Magnificent in themselves and, for many centuries, content to bask in the sunlight and rain of their mythic renown, these monuments have in the last century and a half become increasingly dependent on the tributes paid to them in the form and currency of photographs. (If Martin Parr, in his book *Small World*, showed this economy in action, then in a perfect world – a perfect small world,

as it were – one of Curtis's pictures would show Parr in the process of snapping a grinning group of Chinese or a couple of earnest Scandinavians. That would circle the photo-graphic square, so to speak.) Without the daily and annual testimony of photographs monuments would crumble in the sense that they would disappear from tourists' itineraries – how could a place be worth visiting if no-one had bothered photographing it? Effectively, it would cease to exist. And so, in a sense, views of rubble- and garbage-strewn emptiness at Giza or Hollywood are prophetic glimpses of what such places – sites of eroded or vacated meaning – might look like when that has come to pass. In this light they are photographs showing a world in which there is no reason to go somewhere and nothing to see when you get there. In such a world there are only photo-graphs and – look behind you! – people looking at them.

Geoff Dyer

Geoff Dyer's many books include *But Beautiful* and *The Ongoing Moment*. His books have been translated into twenty-four languages.

This book is dedicated to my wife Bongsu Park for all of her encouragement, advice, patience and love.

I would also like to thank all those who have encouraged, advised, supported and facilitated this project over the last few years: Viv Albertine, Katy Barron, Martin Brierley, Brenda Curtis, Lionel Curtis, Anna Curtis, Richard Coll, Christine Cort, Michael Donald, Andi d'Sa, Geoff Dyer, Martin Foster, Kim Griffin, Joanna Hogg, Cristian Insunza, Vadim Jean, James Johnstone, Chris Keeble, Clare Kilner, Stephanie King, Orsi Kmetty, Andy Lambert, Victoria Labalme, Dewi Lewis, Dave Lucken, Prof. Steve Macleod, Alasdair Macleod, Imaan Mac Quena, Zadoc Nava, Toby Newman, Fernando Oretga, Frank Oz, James Pilkington, Marco Pinesi, Dylanne Powell, theprintspace, Nick Renton, Patricio Schmidt, Col Spector, Sally Stiff, Andrew Sutton, Mitra Tabrizian, Rachael Taylor, Nick Turvey, Nathan Wake, Caroline Warhurst, Katie Webb, Tom Webb, Anda Winters, Paz Zoega

First published in the UK in 2016 by
Dewi Lewis Publishing
8 Broomfield Road, Heaton Moor
Stockport SK4 4ND, England

ISBN: 978-1-911306-04-7

Design: Dewi Lewis Publishing
Print: EBS, Verona, Italy

www.dewilewis.com
www.olivercurtisphotography.co.uk